The Rothko Chapel
Writings on Art and the
Threshold of the Divine

The Rothko Chapel
Writings on Art and the Threshold of the Divine
Dominique de Menil

 Copyright © 2010 by the Rothko Chapel

 Second Printing, May 2011

 www.rothkochapel.org

 All rights reserved. This book may not be reproduced in full or in part, including illustrations, in any form (beyond that copying permitted by sections 107 and 108 of the U.S. Copyright Law and except by reviewers for the public press), without express written permission from the publishers.

 Edited by Polly Koch, Diane Lovejoy, and Frances Carter Stephens

 Printed in Houston, Texas

 Photography by David Crossley except where otherwise noted

 Distributed by Yale University Press
 New Haven and London
 www.yalebooks.com

 Library of Congress Control Number: 2010933025

 ISBN 978-0-300-16777-1

The Rothko Chapel
Writings on Art and the
Threshold of the Divine

Dominique de Menil

Forewords by Fariha de Menil Friedrich
and Christopher Rothko
Introduction by Emilee Dawn Whitehurst

A Rothko Chapel Book
Distributed by Yale University Press,
New Haven and London

6	Foreword by Fariha de Menil Friedrich
9	Foreword by Christopher Rothko
10	Acknowledgements
12	Introduction

WRITINGS

17	Inaugural Address at the Rothko Chapel, February 26, 1971
20	Address at the Opening of the Rothko Chapel, February 27, 1971
24	Dedicatory Address for Barnett Newman's *Broken Obelisk*, February 28, 1971
26	Welcoming Speech at "Traditional Modes of Contemplation and Action in World Religions," Rothko Chapel Colloquium I, July 22, 1973
28	Commentary on the Rothko Chapel from an Interview by Les Levine Published by *Arts Magazine*, March 1974
36	Address at "Toward a New Strategy for Development," Rothko Chapel Colloquium III, February 3, 1977
39	Letter to the Religious Leaders of Houston, December 1, 1977
41	Thanks to the Whirling Dervishes after Their Performance at the Rothko Chapel, October 1978
43	Introduction of Congressman Ronald V. Dellums, January 15, 1981
46	Statement at the First Rothko Chapel Awards for Commitment to Truth and Freedom, June 20, 1981
48	Welcoming Speech at "Islam: A Spiritual Message and a Quest for Justice," Rothko Chapel Colloquium IV, October 21–25, 1981
52	Statement at the Second Rothko Chapel Awards for Commitment to Truth and Freedom, December 10, 1986

54	Comments at the Awarding of the Carter–Menil Human Rights Prize 1986, December 10, 1986
55	Remarks at the Presentation of the Second Oscar Romero Award, March 24, 1988
57	Talk at the Rothko Symposium, Yale University Art Gallery, Sponsored by the Yale Institute of Sacred Music, Worship and the Arts, December 1–3, 1989
60	Remarks at the Ceremony for the Third Oscar Romero Award, Washington, D.C., April 24, 1990
63	Comments at the Awarding of the Carter–Menil Human Rights Prize 1990, December 10, 1990
90	Opening Remarks at "Christianity and Churches on the Eve of the Vatican II," Rothko Chapel Colloquium VI, January 12–15, 1991
92	Remarks at a Dinner Honoring Nelson Mandela and Introducing the 1991 Recipients of the Carter–Menil Human Rights Prize, December 7, 1991
93	A Statement, 1991
95	Acceptance Speech on the Occasion of Receiving the 1992 Christian Culture Series Gold Medal Award from Assumption University, Windsor, Ontario, Canada, March 8, 1992
102	Unpublished Opinion, "We Should Not Forget and Must Not Remain Silent," November 1993
105	Remarks at the Ceremony for the Fifth Oscar Romero Award, Vienna, Austria, June 16, 1993
110	Remarks at the Ceremony for the Sixth Oscar Romero Award, January 11, 1997
113	Notes

Foreword

Glimpses

Fariha de Menil Friedrich

Mother, whirling here and there through the open garage that had become a temporary painting studio. Pots of paint in all directions, glue cooking on the stove that I would taste, mother mixing colors, painting colors onto boards…she loved colors. She loved to create. I knew she was inspired. Maybe Charles James had opened her heart to explore color and texture for herself. Maybe it was Father Couturier, whom she quoted almost daily, the Benedictine who brought art back into the Church. Truth and beauty were one in his eyes.

Her husband too, Jean, a man who loved beauty and a man of courage, compassionate with those who suffered and were overlooked. He would not flinch when it came to helping someone in need. He had been in need. He had grown up poor and worked hard. He married the woman he adored. And he supported her to be who she was. Together, they were together. They slept in one bed. Their union brought five children, five beautiful fingers on one hand. Her hand was full.

Mother read her Gospel in bed, at night, in the morning. A little book, the size you could put into your pocket without anyone noticing, leather bound and worn from the companionship. Underlined, comments in the margin. Every day she read the words of the Beloved Master. He was the one she loved most and trusted most. How to live this love herself…She struggled with her Huguenot inheritance, a certain rationality and asceticism that veiled her from the warmth of her heart. She strove to overcome it daily…through the presence of beauty… through connecting to people, and their tragedies…sometimes

you could find her weeping alone, for herself and for others.

The Chapel of Matisse had been in their hearts, hers and Jean's. Then they met Mark Rothko who could paint the mystery of God, and they built a Chapel in Houston for all people. No one was to be left out. Was not this the way of Jesus… bringing love, inviting everyone, joining those who had been separated, helping the oppressed? Jean died right after the dedication. She remained. The Chapel became the voice of her heart. She was there to receive people. They came from every sacred tradition, she prayed with them. Those who had been oppressed came, she encouraged them. People came seeking beauty, and she inspired them. People were the way. And she found companions of the spirit, so many great ones, the ones who were known and wrote books, the hidden ones who had spent their lives helping others, and those who worked devotedly on her side…Elsian, Nabila, Helen, Paul, Walter, Gladys, Ollie, Manni, her children, the artists, Father Moubarac, Father Scrima, Raimon Panikkar, Nelson Mandela, President Jimmy Carter, Rigoberta Menchú, the Whirling Dervishes dancing in ecstasy, Shaykh Muzaffer Ozak, the Sufi master who hugged her heart and gave her a Sufi rosary which she began reciting every day along with her Christian rosary. She told me that she was a Christian Sufi.

In the first week after she came home from the hospital she told stories to her children and grandchildren who stood around her bed. They drank sherry with her while she sipped it from her sponge. In the second week she moved to a place between this world and the next. Her voice you could barely hear and she

spoke little. We held our heads near her mouth when she wanted to say something. Yet she seemed very happy, like someone in ecstasy.

At some moment she began to move her lips and I leaned closer to her. She whispered, as though revealing a secret, "God waits for us to create Him." "What did you say, mother?" "God waits for us to create Him," she whispered again. It was clear. It was what she was seeing. It was the essence of what she had lived. And it was her gift to us, to all who loved her. She was telling us that we have the responsibility to reveal God, each in our own way, moment by moment… as we breathe, as we speak, as we move through our life. We create God by being. Without us God is invisible.

Two days later she left… leaving with us what does not disappear, the beautiful truth of the human spirit. She leaves us the manifestations of love and courage that she and Jean and so many others created together. She leaves us with a better understanding of who we are.

Foreword

Christopher Rothko

The sense of history that pervades this modest volume lends it a weight that far exceeds its physical properties. The sense of occasion is everywhere and quickly transports one to moments of great significance glossed in these brief statements by Dominique de Menil. To read them is to be amazed anew by her eloquence, her ability to capture, in a few words, the essence of the questions before her and the passion of her response.

However beautiful they may be, Dominique de Menil's comments did not serve esthetic ends, but functioned as remarkable sources of inspiration and motivation. Her ideas do not lie static upon the page but leap off, spurring a quickening of our own thoughts and sparking a spring in our step to realize them.

And yet, for all its boldness, hers is foremost a voice of humility. She appeals repeatedly to our common humanity, not from a special pedestal, but from very much amongst us. She is a woman with sleeves rolled up, valuing what makes her like her fellow human beings, not what sets her apart.

Ultimately Dominique de Menil's words are so powerful because we know that her actions fulfilled them. In concert with her husband John, hers was a life of borders crossed, contradictions dared, objections dispatched, and conventions overruled; a legacy of convictions lived.

The Rothko Chapel is a timeless embodiment of the de Menils' spirit, a gift of their foresight. This collection of writings adds a little texture to its walls, wafts some incense through its air and casts a glow from its skylight. It is a marvelous echo of a voice that still speaks to us; one that will always inhabit the present.

Acknowledgements

Grateful acknowledgement is made to the following for the publication of this collection:

First and foremost to Suna Umari, Chapel historian and archivist for collecting, organizing, and fact checking the speeches and for her decades of dedication to the Rothko Chapel.

To Frances T. Farenthold, honorary director, for her dedication to the Chapel and her efforts to raise funds for the book's publication.

To the many generous funders whose contributions have made this publication possible:

Susie and David Askanase in memory of Reuben Askanase, one of the founding directors of the Rothko Chapel; Toni and Jeff Beauchamp; Jody Blazek and David Crossley; Rose C. Bourgin; Ann Bragdon and Karim Alkadhi; Anne and Peter Brown; Mary Ann Bruni; Kathleen and Glen Cambor; Gayle and Mike DeGeurin; Gayle and Thomas De Gregori; Emilie Kilgore; Karl Kilian; Tom Kleven; Marilyn Oshman; Macey and Harry Reasoner; Louisa Sarofim; Sande Schlumberger; Jerome Seydoux; Bapsi Sidhwa; Nita and Dinesh Singhal; Margaret and Louis Skidmore; Michael S. Stude; Martha Claire Tompkins; Andrea and Bill White; Helen Winkler Fosdick; Peter H. Wood; and Lynn and Oscar Wyatt.

To Christopher Rothko and Fariha de Menil Friedrich, children of visionaries and members of the Chapel's board of directors, for their eloquent and personal forewards and to Emilee Dawn Whitehurst, executive director, for her apt introductory remarks.

To Stephen Fox, architectural historian and Chapel advisor, for his eye for excellence.

To David Crossley, whose images are an indelible record of the vibrant life of the Chapel. To Minor Design for the elegant book design.

To editors Diane Lovejoy, who forged the connection with Yale University Press and generously donated time to the project, and Frances Carter Stephens, communications director, who guided the book through final editing and production. To Patricia Fidler, publisher, art and architecture, at Yale University Press and her colleagues Lindsay Toland, art book publishing coordinator, and Paige Jokl, publicist.

And finally, to the Chapel's board of directors and honorary directors who lovingly shepherd this institution: Arthur Bellinzoni, Ph.D.; Philip Bobbitt; Gayle Ross DeGeurin; The Hon. Donald B. Easum; Joe Eldridge, Th.D.; Frances T. Farenthold; Fariha de Menil Friedrich; Asma Kombargi, Ph.D.; Willy F. Kuehn; Susan Rappaport; Christopher Rothko, Ph.D.; Jacqueline André Schmeal; Dinesh Singhal, Esq.; Ronald C. Slye; and Martha Claire Tompkins.

Introduction

Emilee Dawn Whitehurst

In celebration of its fortieth anniversary, the Rothko Chapel has collected for the first time the speeches, writings, and interviews related to the Chapel given by co-founder Dominique de Menil, from the dedication of the Chapel in 1971 to her death in 1997. Her insights into Mark Rothko's artistic genius remain fresh and provoke the reader to contemplate anew the transformative power of art. Her voice issues a clarion call to remember that spiritual forces are of consequence in real world affairs and that a capacity for reverence sustains a commitment to justice.

Hailed as one of the great artistic achievements of the midtwentieth century, the Rothko Chapel, located in Houston, Texas, is an intimate sanctuary designed around fourteen monumental canvases by the renowned painter Mark Rothko (1903-1970).

Chapel founders John and Dominique de Menil commissioned Mark Rothko in 1964 to create a chapel for St. Thomas University, a Catholic institution. Before it was built, however, they decided to free it from any denominational ties so that it could instead serve as a sacred space for people of every belief.

The Rothko Chapel was dedicated on February 27, 1971 to provide a place of worship, meditation, and prayer for people of all faiths every day of the year. The Chapel and its programs were to serve as a focal point for people to gather and explore spiritual bonds common to all, to discuss human problems of worldwide interest, and to share a spiritual experience, each loyal to one's own belief, each respectful of the beliefs of others.

The Chapel has faithfully fulfilled its vocation for the past forty years, welcoming thousands of visitors and pilgrims from all over the world through its doors.

Listed in the National Register of Historic Places, the Chapel has become a premiere destination for international visitors passionate about art and spirituality. The Chapel is surrounded by a verdant park dominated by artist Barnett Newman's magnificent sculpture, *Broken Obelisk*, which is dedicated to the Reverend Dr. Martin Luther King, Jr.

Alive with religious expressions of all faiths, the Chapel fosters interfaith awareness and serves as a symbol of mutual respect. Over the years its programming has consistently raised the banner of human rights and the Chapel has become a rallying place for those concerned with peace, freedom, and social justice throughout the globe.

This small volume is a testament to the prescient wisdom that shaped Mrs. de Menil's intellectual and spiritual leadership during the Chapel's formative years. Her presence enabled the Chapel to achieve a seamless synthesis of art, interfaith understanding, and justice. In doing so, the Chapel stands alone as an institution of unparalleled distinctiveness and integrity, as a place that invites all who visit to approach and perhaps transcend the threshold of the Divine. In tribute to Mrs. de Menil's commanding vision and Mark Rothko's exceptional achievement, the Chapel looks forward to the next forty years with great anticipation and joy.

Except where noted,
all remarks by Dominique de Menil
were delivered at the Rothko Chapel
in Houston, Texas.

The struggle for human rights
 must be at the forefront of all that we do.

Inaugural Address at the Rothko Chapel

February 26, 1971

I am quite moved to be here because tonight is the real event. It is the first time that people are together in the Chapel. Tomorrow there will be here heads of religious communities who have come from afar, and it is wonderful. Tonight there are YOU, the people who are going to use the Chapel. The people who will give it life.

I am supposed to talk about the paintings by Mark Rothko, but I don't think I can explain them. I don't think that what I say or anyone says is the last word. I think the paintings themselves will tell us what to think of them—if we give them a chance. They will educate us to judge them. Every work of art establishes its own base for criticism. Every work of art creates the climate in which it can be understood.

Mark Rothko was very eloquent on the subject. He said,

> *A picture lives by companionship, expanding and quickening in the eyes of the sensitive observer. It dies by the same token. It is therefore risky to send it out into the world. How often it must be impaired by the eyes of the unfeeling and the cruelty of the impotent.*

This attitude of receptivity, indispensable in art, is also the attitude necessary for ecumenism—TO LISTEN.

For centuries, religious leaders, missionaries, have done all the talking. There was nothing wrong in the talking except that it never stopped. Those who were talked to never had a chance to respond. It was never assumed that they might have something to contribute, some tradition, some personal experience.

There is a growing awareness that God does not only speak through his appointed ministers—that he may be at work everywhere in the world. Everywhere people of goodwill get together. Everywhere creative people are trying to open a new door. There is always more than meets the eye in an authentic work of art.

At first we might be disappointed at the lack of glamour in the paintings surrounding us.

The more I live with them, the more impressed I am. Rothko wanted to bring his paintings to the greatest poignancy of which they were capable. He wanted them to be intimate and timeless.

Indeed they are intimate and timeless. They embrace us without enclosing us. Their dark surfaces do not stop the gaze. A light surface is active—it stops the eye. But we can gaze right through these purplish browns, gaze into the infinite.

They are warm, too. There is a glow in the central panel. Rothko told me that he wanted to recreate the same opposition, the same tension, that exists in Torcello's church. The last judgment at the door, and the inviting and glorious apse.

If there is such a message, we are grateful it is delivered without images. Images, which were never acceptable to Jews and Muslims, have become intolerable to all of us today. It might be an important sign that we cannot represent Jesus or his apostles anymore. Any representation that is not naive is unbearable. The sculptors of the twelfth and thirteenth centuries were naive people, visually speaking. Only in the exaltation of the Renaissance was it possible for Michelangelo to still represent God as a bearded man. But nobody is visually naive any longer. We are

cluttered with images, and only abstract art can bring us to
the threshold of the divine.

It took courage for Rothko to paint nocturnal murals. But I
feel that it was his greatness. Painters become great only through
obstinacy and courage. Think of Rembrandt. Think of Francisco
de Goya. Think of Paul Cézanne.

Rothko was prophetic in leaving us a nocturnal environment.
Night is peaceful. Night is pregnant with life.

Charles Péguy, the French poet, praised the night. To him the
night was the *reserve of being, the great continuous fabric,* and
the days were only holes in the fabric, holes that ruptured the night
like piercing sound, little windows giving only a vacillating and
disquieting light.

And he made God say, *The night is my most beautiful creation.*

These paintings, too, are probably the most beautiful creation
of Mark Rothko. ◊

To him the night was the reserve of being, the great continuous fabric,

and the days were only holes in the fabric, holes that ruptured the night

like piercing sound, little windows giving only a vacillating and dis-

quieting light.

Address at the Opening of the Rothko Chapel

February 27, 1971

This is an exceptional assembly of men of God, representing each a great multitude, and an assembly also of artists and poets, of writers and art lovers, of men and women of goodwill.

I do not feel adequate to address this remarkable assembly. I'm on the side of St. Paul who felt women should keep silent in public. I know also that we have among us five or six or more of the best art historians in the country, and this, too, should silence me.

They have gone as far as it is possible to describe the indescribable quality of Mark Rothko's art. They have evoked *the enigmatic, gripping presence of his paintings, the ineffable beyond-everything sensation.* They have talked of the *disembodied absolute*, of an image of the *not-seen*.

Rather than attempt to elaborate on what they have said, and so well said, already, I would like to recall two events that occurred before and after the Second World War. The influence they had on us was decisive. In January 1936, Father Yves Congar delivered eight lectures on ecumenism that marked the beginning of his ecumenical career. I had the privilege to hear him, and it marked me for life.

In the summer of 1952, we visited with Father Marie-Alain Couturier, another Dominican, the churches where Fernand Léger and Henri Matisse, two towering artists of their time, had contributed their greatest work. We visited also the site where Le Corbusier was going to build his famous Chapel of Ronchamp. We saw what a master could do for a religious building when he is given a free hand. He can exalt and uplift as no one else.

The influence of those events was lasting. If we played a part in the birth of this Chapel, which indeed we did, it stems from the orientation we received in those early days through those two men.

But this Chapel has deeper roots than our own involvement. It is rooted in the growing awareness that love and the search for truth are unifying principles. It is rooted in the growing hope that communities who worship God should find in their common aspiration the possibility of dialogue with one another in a spirit of respect and love. This hope, this nostalgia, explains the Chapel, as it explains many spontaneous initiatives of brotherhood coming up all over the world today among religious people.

The rest is goodwill and circumstances—the goodwill and circumstances that led to the foundation of the Institute of Religion and Human Development in the midst of a fast-growing medical center and in the very city where cosmic explorations are planned.

Looking back at the many circumstances that led to the extraordinary combination of the Institute of Religion and Human Development, the Rothko Chapel, and the Barnett Newman *Broken Obelisk* dedicated to the memory of Martin Luther King, Jr., one cannot help thinking that a providential thread links all these circumstances.

Barnett Newman, painter as well as sculptor, was another great artist who would have loved to receive a religious commission. It was an extraordinary coincidence that he should be represented here by one of his major works.

But Rothko had somehow set himself aside for this great task. It seems that the paintings he did in the last ten years were a sort of preparation for the Chapel.

The deep brownish and purplish red had appeared already in large canvases painted in 1958 and 1959. From this time on, it became his basic and recurrent color, the color elected to bring his paintings to their maximum of poignancy, as he said. As he worked on the Chapel, which was to be the greatest adventure of his life, his colors became darker and darker, as if he were bringing us to the threshold of transcendence, the mystery of the cosmos, the tragic mystery of our perishable condition. The silence of God, the unbearable silence of God.

And here again I wonder if it is not prophetic that Rothko should have left us the one message that can be totally accepted by everyone, believers as well as nonbelievers: the sense of mystery.

Rothko had the stubbornness of a man chosen by God. Nothing could deviate him from his single purpose, and this purpose forced him to use darker and darker reds. He would have liked to use more beguiling colors. He tried, he told me, but he had to renounce these pleasurable options.

Like all great artists who follow an inner call, he sacrificed everything superfluous to his vision. The message he had to deliver was a timeless one. It was a vision of simplicity, a message

of silence. An inviting silence, a regenerating silence. There is warmth in these paintings. They embrace us without enclosing us. The eye and the mind go through into the infinite. There is a faint glow in the central panel of the central triptych, and this faint glow is like a whispering voice.

It is not unfitting to recall here the passage of I Kings:11–13, where God talks to Elijah:

A strong and heavy wind was rending the mountains and crushing the rocks before the Lord — but the Lord was not in the wind. After the wind there was an earthquake — but the Lord was not in the earthquake. After the earthquake there was fire — but the Lord was not in the fire. After the fire there was a tiny whispering sound. When he heard this, Elijah hid his face in his cloak and went and stood at the entrance of the cave. A voice said to him, "Elijah, why are you here?" ◊

Dedicatory Address for Barnett Newman's *Broken Obelisk*

February 28, 1971

Mrs. Barnett Newman, who is here with us now, wishes me to state that the *Broken Obelisk* by her late husband, Barnett Newman, was finished in 1967. It was four years in the making from an idea first conceived about 1960. It was not commissioned, and the artist was very concerned about where it would be installed. He saw and liked the site of the Institute of Religion and Human Development. The concept of setting the *Broken Obelisk* in a reflecting pool was his suggestion.

Great artists are gift givers. The treasures they leave to mankind are priceless.

The *Broken Obelisk* by Barnett Newman is one of these treasures. As an outdoor sculpture, it can be enjoyed at all times—at sunrise or at sunset—at noon or at midnight.

Its simple beauty can be felt by all, easterners and westerners, black and white, young and old.

The massive pyramid base suggests stability and determination. The obelisk resting on the apex suggests an upward thrust. The sudden break reminds us that interruptions, even dramatic interruptions, are part of life.

As you know, books and art objects are often given to a library or a museum in memory of a friend. Having a profound admiration for the late Dr. Martin Luther King, Jr. and wanting to honor him, John and I are giving this sculpture in his memory to the citizens of Houston, and we have entrusted it to the Institute of Religion and Human Development.

We have here both a Chapel and a monument. A place for worship and a memorial to a great leader. The association of these

two remarkable sites should tell us over and over again that spiritual life and active life should remain united.

It should tell us over and over again that whoever believes he loves God and does not love his neighbor is deceiving himself.

It should remind us over and over again that there is no love without justice. ◊

Great artists are gift givers.
The treasures they leave to mankind
are priceless.

Welcoming Speech at "Traditional Modes of Contemplation and Action in World Religions," Rothko Chapel Colloquium I

July 22, 1973

On behalf of the Menil Foundation and friends in Houston, I would like to greet the participants in the first ecumenical meeting of the Rothko Chapel—and tell them of the joy we all feel at having them here.

When a child was born in my family, my father used to say simply, "Elle est là!" ("She is here!"), because in those days there were only girls—boys came later. Well, "You are here," and to me it is like a birth.

No birth is easy; we know it was not easy for you to come. You all have tight schedules and heavy commitments. So I want to express to you our thanks. We are grateful to the steering committee, which did such beautiful work, particularly to Professor Yusuf Ibish. Without his devotion, patience, and hard work, this remarkable meeting would not have taken place.

I want you to know that you have been desired—and from way back. It was like a call in the night. The man who desired you most is not here with us. As you know, my husband died in June. Yet in some invisible way, his presence remains. He left us a working tool and an ideal. The tool is the Menil Foundation. The ideal is embodied in the Rothko Chapel.

If I try to sum up John's ideal, I keep coming back to such words as *honesty* and *truthfulness* and *brotherhood*.

A brotherhood that leaves no one out, no section of humanity, particularly not those who are always excluded.

He himself started in life at the bottom of the ladder. He vowed that if he ever got to a position of authority, he would not forget those who see things from below, those who are never given a voice.

He went right ahead, pushing aside social patterns and prejudices. His moves were brusque and uncompromising, and naturally he ruffled some feathers.

He had a passion for crossing borders, for establishing contacts with "the others." But it never led him to lower his standards. He was impatient with mediocrity. He saw mediocrity in noncommittal attitudes. He wanted to face issues, to fight the natural inclination to settle for solutions that offend no one but have no merit, solutions of mediocrity.

He never paid anyone with words and he never paid himself with words. He was ruthlessly honest.

To me, John's fundamental honesty and his hunger for brotherhood are two guiding principles.

This is what you are about to do. We at the foundation are aware of the immensely difficult task you have set for yourself: to communicate the incommunicable, express the inexpressible, look at the invisible. And to use clumsy words, fraught with emotion, even charged with aggression. And also words that have no fixed density, not even definite contours.

We cannot help you in your work, but we offer you the Rothko Chapel as more than a convenient meeting place. It is a place where a great artist turned toward the absolute, had the courage to paint almost nothing, and did it masterfully. It is a place blessed by the many people who gather there to meditate, to find themselves, and to go beyond themselves. It is a place that was solemnly dedicated to love, to God, to the absolute truth you are after. ◊

COMMENTARY ON THE ROTHKO CHAPEL FROM AN INTERVIEW BY
LES LEVINE PUBLISHED BY *ARTS MAGAZINE*

March 1974

INSIPIDNESS AND UGLINESS

Since its dedication in 1971, the functions of the Rothko Chapel have been both modest and very ambitious. On one hand, the Chapel is like a big, old tree in the shade of which anyone can sit. On the other hand, it is a place dedicated to transcending borders.

Strangely enough, lots of people—mostly young people—come to the Chapel and just sit there. Some stay a short time; some a very long time. Many come regularly, once a week, once a month. Some sit in the lotus position for an hour or more.

Maybe this constant stream of visitors is due to the fact that there is no other place in town where you can be by yourself in silence. In Europe old churches fill that role, and in Muslim countries it is the mosque. In a mosque, in a Catholic church, and, no doubt, in many temples throughout the world, there is an atmosphere that does not exist elsewhere. It has to do, of course, with the sacredness of the place. One can be isolated and yet not alone. There is both solitude and warmth—one feels in the center of the world and yet without any outside interference.

In Houston the Rothko Chapel fills that role. Modern churches—Protestant and Catholic alike, as well as synagogues—are too damn awful. You cannot find solitude there because you are being continuously assaulted by insipidness and ugliness. It is most disturbing to be surrounded by visual mediocrity.

Great works of art do not jump aggressively at you—they tend to look natural. Not all of them, of course—some are so overwhelming that they almost knock you down.

THE INFINITE WITH THE FINITE

The Mark Rothko paintings are very quiet, very silent. It's almost as if they were not there—they really do not demand any attention, yet they have a presence.

To a certain extent, they remind us that Rothko had the audacity to paint them just like that, so big and so dark. As you know, he talked very little about them. But words were not necessary to feel that they meant terribly much to him and that he hoped they would also mean a great deal to others.

They are like the veil in the temple of Jerusalem. When the Romans conquered Jerusalem and forced their way into the temple, they were very surprised to find nothing in the holy of holies. The Rothko Chapel provides the same kind of dialectical tension: nothing and everything. Concretely speaking, there is nothing there but stretched cotton duck soaked with a mixture of alizarin crimson and black. But aesthetically speaking, there is one of the most daring endeavors ever undertaken to express the infinite with the finite. This is a kind of tightrope-walking. But isn't every great work of art tightrope-walking?

Rothko's choice of dark colors is daring and yet so rewarding. A dark color does not stop the gaze as a bright one would. The walls of the Chapel do not limit our vision—the eye goes beyond. There is a feeling of infinity and yet there is warmth. With other means the same feeling is obtained in a mosque: the repetition of columns gives a feeling of infinity, and the carpets and ceiling decorations, a feeling of warmth.

THE "NO-MAN'S-LAND OF GOD"

When you come to think of it, the role of the Rothko Chapel is one of hospitality—there is this basic hospitality offered to anyone who comes to meditate, and it might well be the most important aspect. But there are others.

Where do a Muslim and a Quaker go when they want to be married in a sacred place without pressure or interference? To the Rothko Chapel. People in love do not want to marry in the office of a judge, not even in a friend's living room. They want God to be their witness. Even if they claim they don't believe in God, they want their marriage to be religious—because love postulates eternity.

This vocation of hospitality at the Chapel extends to groups. A yoga meditation group meets there every Monday, and the Hindu Worship Society of Houston meets every second Sunday of the month. The Islamic Society of Greater Houston feels quite at home in the Chapel—before they had a place of their own, they used the Chapel for their weekly meeting of prayers. They still use it for their two great annual celebrations: *Eid-el-Fitr* and *Eid-el-Adha*. Vigils for peace have taken place in the Chapel, as well as a ceremony of penance by Christians asking God's forgiveness for their crimes against Jews.

These ceremonies bring together mostly people who are bound by a common faith or common ideal. The Chapel must go beyond opening its doors to those who are already united. It must provide a common place where men and women of different

traditions can meet and experience their brotherhood. By common place, I don't mean a neutral place—I mean a place that belongs to all in common. The "no-man's-land of God," as it has been called.

The Chapel must go beyond opening its doors to those who are already united. It must provide a common place where men and women of different traditions can meet and experience their brotherhood.

ECONOMIC COLLAPSES, POLICE STATES, ATOMIC WARFARE

Neutrality is admirable—it can even be heroic—but it is standoffish. I see the vocation of the Rothko Chapel as active. Not a militant activity—no—just the opposite. If you have guests in your house, a great joy is to provide opportunities for conversation. To stimulate and to conduct conversations, with several people participating, once was an art at which some women excelled. The places where such conversations happened were called "salons." The elitist connotation the word has today does not translate into the warm and carefree atmosphere that existed. There was a congeniality in which ideas germinated, projects took shape, notions were sharpened.

I mention salons only because they recall the basic need of rubbing ideas, and not only elbows as at cocktail parties. Today we need to rub more than ideas: we need to rub hearts. Churches and synagogues are too much like clubs, and as we all know, clubs are meant to keep people out. Maybe this is why so many of the young are staying away. They have no use for clubs; they have a thirst for brotherhood—a brotherhood that includes everybody, every race, every creed. They are attuned to what is happening in the world. Their sensitivity has not been blunted; they are aware of the famines and the wars and the torture. They know that we are threatened by economic collapses, police states, atomic warfare. They try to do something about it, but they don't know how and what. Their helplessness has reduced them to disorderly acts, which lead nowhere.

RECORD ON VIDEO TAPE

The Rothko Chapel could give them hope and courage by taking the lead. I see there a series of great encounters that would bring together brains and hearts—fresh brains and experienced brains, young hearts and hearts enlarged by life.

A colloquium took place at the Chapel in December 1973. We wanted to commemorate the twenty-fifth anniversary of the Universal Declaration of Human Rights by the United Nations. It was a great thing that the United Nations signed such a Declaration, but nothing was ever done with it. People in their thirties went through eight years of elementary school, four years of high

school, four years of college, and four years of graduate school—twenty years—without ever hearing about it.

The colloquium was called "The Human Reality." It brought together three scientists and two men of faith who explored what man is and how his authentic human destiny could be accomplished. Debates were open to the public and many participated—people actively engaged. Everything was recorded on videotape. The tapes are so alive that they offer the possibility of stretching the colloquium in time and space with proper distribution.

This possibility of stretching an encounter at the Rothko Chapel in time and space can be far-reaching—it is a fantastic incentive to organize further encounters.

It is not enough to understand the human reality, something must be done to make it more real and more human.

AN APPARATUS OF OPPRESSION

We are planning an encounter with economists, social scientists, businessmen, and politicians. It will still be on the theme of human reality, but this time we must involve those who make decisions in the world. It is not enough to understand the human reality; something must be done to make it more real and more human.

When people meet in the Rothko Chapel, they know they meet in a place that was dedicated to God for the express purpose of fostering brotherhood, love, understanding. The mere fact of assembling in the Chapel gives a spiritual orientation to the debates. It means that man's reality implies transcendence. This may look to many as a marginal circumstance—to me it is central.

The world is in a precarious state. In many sectors people live in subhuman conditions. In some parts of the world (Russia and China), famine has been eradicated, but the organization of life does not leave any freedom to the individual—man has to conform to the pattern of the community or he is disposed of. Men and women exist only as cogs in a big machine or as ants in an anthill. They exist only for society, and society does not allow them to follow their own artistic, intellectual, philosophical, religious development. Frankly, this is nothing so very new. In great past civilizations, people had to conform, and the interests of the state (rightly or wrongly understood) always prevailed over the individual. Inquisition existed long before the word was invented. The Persian Empire, the Roman Empire, the Byzantine Empire, the Venetian Republic, they all had their secret police, and an individual did not weigh much if he were thought to be against the state.

The great problem today is to organize life on the planet in such a way that the distribution of wealth will be more just without creating an apparatus of oppression.

IMPROVE THE WORLD

My conviction is that all attempts at civilization will turn into insect societies—well-working societies on the model of China, for instance—unless the total human reality is taken into account. If society in its organizing efforts suppresses the deepest aspirations of man—his transcendental component—we will have large communities where man will indeed be reduced to the condition of an insect.

All over in free countries, there are wonderful signs of people in search of new directions—God-oriented—in search of brotherhood, in search of ways and means to promote the harmonious development of man. I hope the Rothko Chapel will be a place where brotherhood will become a reality, a place where people will become aware of man's total reality and will be moved to improve the world. ◊

Address at "Toward a New Strategy for Development,"
Rothko Chapel Colloquium III

February 3, 1977

We have invited you here tonight to give you an inkling of what the Rothko Chapel stands for.

All of us associated with the Chapel have found out that it has a life of its own—it answers many needs and responds to deep aspirations.

The word *chapel* was adopted reluctantly for lack of a better word—it sounded too churchy, too sectarian—but it turned out to be a good choice. It was pointed out to me recently that the word chapel comes from cape, actually the cape of St. Martin of Tours, which he cut in two and shared with a poor man. After his death, the cape, or rather the half-cape, was kept as a relic. A shrine was built to house it, which became known as the *capella*. It was the first chapel.

So a chapel should remind us of sharing: sharing views, sharing religious experiences, sharing social problems. To this idea of sharing, of human community, of encounters, Mark Rothko brought his own message. It is a message that is not immediately understood, yet one that grows with time.

The dark paintings of the Rothko Chapel have startled many visitors who associate darkness with gloom. Those familiar with Rothko's earlier paintings miss the bright oranges and yellows, the pinks and greens. Most people are unprepared for the *monumental gravity of these vertical panels*, for the *brooding solemnity of their somber colors*. They feel plunged into the night.

Indeed it is the night—but not quite. Even in the dim light, purplish color slowly emerges from the darkness ... it is predawn.

The Chapel paintings are a supreme achievement of Rothko's life. They are the expression of an artist deeply moved by the tragedy of the human condition. They are an endeavor to go beyond art. They are an attempt to create a timeless space.

Rothko used to say that he wanted to bring his paintings to their utmost poignancy. This search for poignancy was a search for the infinite, for the absolute. Like all searches for the infinite, it emerged in darkness and silence.

Silence is so accurate, he said once to a friend. Many young people have understood this message of silence. They come here often. They come here to be alone. Alone, yet not lost. With their frequent presence, they are placing a spiritual stamp on the Chapel. With their regular practice of meditation, they are turning it into a "cosmic center." Every place of meditation becomes a cosmic center, a timeless space.

Their gift to their elders is to make us understand the message of Rothko's paintings, to make us conscious of this central position, this axial perspective, to make us aware of intangibles.

Economists' concerns are the tangible: the barrels of oil, the tons of wheat, the labor hours, the G.N.P. percentages. They are the indispensable blood of mankind. Yet intangibles are also part of reality—joy and sorrow, love and hate, hope and despair—and we can no more neglect them than we can neglect the tangibles.

The music you will now hear expresses intangibles.

The first part was selected by Alan Lomax from his vast archive of folk songs. It is the ancestral music of a pastoral and agricultural people. Probably it goes back millennia, possibly to the beginning of Neolithic society.

Man doesn't live anymore in small bands of hunters. He is alone in his field—alone with his herd. When a disaster hits him, when his crop is destroyed, when his animals die, man does not have his community to uphold him. He sings alone. He sings his loneliness, his alienation, his nostalgia.

According to Lomax, this solo singing, so different from communal songs, marks the beginning of classical civilization. It goes all the way from the western Mediterranean shores to Mongolia and Japan.

Then we will hear two Iranian musicians, Daryush Safvat and Nur Al-Din Sarvistani: a sitar player and a singer trained in traditional Persian music. Last we will listen to the fabulous Munir Bashir from Iraq.

All three musicians came to Houston in 1973 for the first colloquium at the Rothko Chapel, "Traditional Modes of Contemplation and Action in World Religions." They performed and were recorded here. They represent the tradition of the East—a tradition eminently conscious of intangibles. ◊

Letter to the Religious Leaders of Houston

December 1, 1977

Fraternal love plays only a minuscule role in society and is practically absent from international life. Love between human groups is not taken seriously as a possibility; it is not even mentioned. In a world filled with mistrust, armed to the teeth and ready to explode, a realistic attitude might be to consider love as an imperative need.

Considering our common failures, our common apathy, we believed that an initiative promoting fraternal love might be well received by religious communities. A modest start might be made. It is just such a modest start that we would like to explore with the religious leaders of Houston.

Admitting that discussion meetings are often sterile, and that social gatherings fall short of providing opportunities for deep fraternal love, we thought, why not consider another approach, an approach that would be more commensurate with, more connatural to, love?

The Rothko Chapel is oriented toward the sacred, and yet it imposes no traditional religious environment. It offers a place where a common orientation could be found—an orientation toward God, named or unnamed, an orientation toward the highest aspirations of man and the most intimate calls of the conscience.

It should be made very clear from the start that praying in common does not imply a common prayer. What we would like to explore here is the possibility of a mutual presence, a loving presence of people belonging to different religions or to no religion. Members of one tradition would offer a prayer, while

members of other traditions would listen in religious silence. Communities would alternate, each presenting a different form of prayer: reading a sacred text, singing in a choir, playing musical instruments, dancing, chanting, humming, burning incense, or just remaining silent. Such meetings could happen once a week, possibly late Sunday afternoon. They would express the will to participate in "A Time of Prayer."

The prerequisite would be genuine respect for other traditions and devotion to one's own. It is not by diluting our respective heritages but by purifying and deepening them that we will be able to get closer to one another.

The Hindu should become a better Hindu, the Buddhist a better Buddhist, the Jew a better Jew, the Christian a better Christian, the Muslim a better Muslim. On this firm ground, we should not be afraid to be together and to listen to one another praying and, deep at heart, to pray ourselves according to our own belief, our own tradition.

Four days before he died, while he was in Calcutta, Thomas Merton met with other contemplatives. At the close of the meeting, he was asked to say a prayer, and he prayed: *...Oh God, who taught us that when we open to one another, you dwell in us, help us to keep that openness and to fight for it with all our heart.* ◊

Thanks to the Whirling Dervishes after Their Performance at the Rothko Chapel

October, 1978

I would like to say a word of thanks to each of you individually.

I would like to thank Mr. Halici very specially. I am extremely grateful to him for his kind and assiduous cooperation. It has been most appreciated.

I want to thank Sheikh Selman Tuzun with all my heart. He has been the keystone of the building forming this ritual. When he became sick, I had the feeling that everything was going to collapse. But I have felt his soaring spirit all along, and it will always remain with me.

I want to thank Khoja Sadeddin Heper very specially. If a tree is judged by its fruits, a master should be judged by his disciples. The performance of the musicians has surpassed everything I had dreamt of in my wildest dreams, and I am grateful that he has made us the beneficiaries of his gifts, his work, and his dedication.

I want to thank the musicians, but I will not pronounce their names for fear of scratching their ultra-sensitive ears. Yet I would like them to know that we have enjoyed each one of them immensely. Each one has contributed something very special. Singers and instrument players have warmed our hearts and lifted our souls so much that our walk will be always lighter from now on.

I would like to express by joyful hallelujahs the thanks I have in my heart for the Master of the Dance and the Semazen. As in the case of the musicians, what has been extraordinary is that their contribution has been made both as a group and as individuals. The group has been more than the addition of each, yet each has contributed something unique. There are no two human beings alike—and thus there are no two Semazen alike. I feel I am not

speaking just for myself when I say that we have been enriched by each one in particular. It is the same ritual, the same movements, and yet, as with the musicians, their performance is the gift of a unique personality. We have felt it and received it.

I want also to thank Mrs. Ayasle. I do it last because we women are always last in a society of men. But Jesus said that the last will be the first, so we don't mind. Mrs. Ayasle has been a source of warmth among us, and her presence will remain with us forever.

As a group and as individuals, you have showered on Houston the blessings of Islam. We have felt its warm breath, and it has quickened our blood.

You have brought to us in a most beautiful way the message of Mevlana: a message of love and joy, a message of universal brotherhood. The world is sick for lack of brotherhood, and you have shown us that it can flourish. Many people have received this message through you. They were so moved that they could not express it: *It is beyond words*, I often heard. The little seed you have sown here will grow with Allah's rain. ◊

The world is sick for lack of brotherhood, and you have shown us that it can flourish.

Introduction of Congressman Ronald V. Dellums

January 15, 1981

To speak to us tonight, we have one of the best men in the Congress of the United States. With him we shall celebrate once more the birthday of Dr. Martin Luther King, Jr., and it will be an occasion to ponder the dangers and the hopes of our time.

Dr. King was one of those rare men who was totally obedient to his conscience. It cost him his life, but it won him the admiration, the respect, and the love of all men of goodwill, both of this generation and all generations hereafter.

Dr. King wanted—for his community, for his country, and for the world at large—peace and happiness. But peace and happiness do not exist without justice, without freedom, and without the basic material needs: food, shelter, health, education.

Yet he knew that, however much we strive for these things, we will get them only if we seek first the Kingdom of God—only if we are first just, honest, generous, compassionate. Seek first the Kingdom of God and his righteousness, and all these shall be added unto you.

Because Dr. King listened to his conscience, he became totally opposed to the war in Vietnam. Because he listened to his conscience without any reservation, he was truly a man of God, and his words are as valid today as they were in 1964. And they are as valid for Europeans as they are for Americans, as valid for Africans as they are for those living in the Near East and Far East, as valid for whites as they are for blacks, as valid for believers as they are for those who are detached from religious traditions.

When I read this morning the biographical sketch of Representative Ronald V. Dellums, I was confirmed in my belief

that his presence tonight would be a marvelous homage to Dr. King, and a great illumination to all of us.

In his still fairly short career (he is only forty-six years old), Mr. Dellums has shown a devotion to his fellow man that is without parallel. He has served in many capacities, particularly in the fields of health and of employment opportunities for all, but most of all by example in his moral commitments and his rethinking of our national policies. The list of his past and present activities is long, but it reveals so well his personality that I shall attempt to go through it briefly.

Ronald V. Dellums was born in Oakland, California, in 1935. He spent two years in the Marine Corps before he earned his BA from San Francisco State College. He then earned a master's in social work from the University of California at Berkeley.

He quickly became a manpower specialist and served as a psychiatric social worker for the California Department of Mental Hygiene from 1962 to 1965.

He was program director of the Bayview Community Center in 1964 and 1965. He was associate director of the Concentrated Employment Program of the San Francisco Economic Opportunity Council in 1967 and 1968, and he served on the Berkeley City Council from 1967 to 1971.

In 1970 Mr. Dellums was elected to the 8th Congressional District of California. He chairs the House Committee of the District of Columbia—he was the first in his congressional class of 1970 to be elected to the chair of a full committee of the House of Representatives.

He is also the chairman of the D.C. Subcommittee on Fiscal Affairs and Health. Dellums is currently the vice chairman of the Congressional Black Caucus and a member of its executive committee.

He is a member of the executive board of the Democratic Congressional Campaign Committee. He is also national co-chairperson of the Democratic Coalition, an organization composed of groups and individuals within the Democratic Party who are committed to party reform and the implementation of progressive programs for the nation.

Like Dr. King, Mr. Dellums took a strong stand against the war in Vietnam. Terminating the war was his first priority when he entered Congress. His fight against war and against racism shows him to be a true disciple of Dr. King, and a great leader.

The Honorable Ronald V. Dellums . . . ◊

Statement at the First Rothko Chapel Awards for Commitment to Truth and Freedom

June 20, 1981

———

The Rothko Chapel is a sanctuary open to all, a no-man's-land of God—named or unnamed—thus every man's land. Its spiritual atmosphere comes not from any traditional religious decoration. It emanates from a majestic ensemble of fourteen dark, reddish panels created by the late artist Mark Rothko.

Affiliated with no particular religion, dependent on no particular group, the Chapel has attracted people in search of peace, meditation, and a more intense consciousness of our time. It has become a center for intercultural and human rights encounters. Every year the birthday of Martin Luther King, Jr. and the anniversary of the United Nations Universal Declaration of Human Rights are celebrated.

In 1981 we mark the tenth anniversary of the Rothko Chapel. It is a good time to reaffirm its vocation and question our faithfulness to it.

It is a vocation so simple, so basically human, that it is understandable by all—yet so difficult to observe. It commits us to honesty, to justice, to compassion. In the end it demands that we recognize "the other" as another "I."

The other—the others!

Millions of them are left to sink. They are asphyxiated, starved, tortured, reduced to silence. Yet, at great risk, a few men and women refuse to bow down in front of hypocrisy, pseudo-truths, inflated authority. Loud or silent, their testimony sends endless echoes around the world.

To such heroic people, many of them anonymous, we dedicate this ceremony. To them and to their struggle for freedom—a

freedom that no authority in the world, be it political, ideological, religious, or economic, should be able to restrict without consent, a freedom belonging to every human being in search of more justice.

The future cannot be closed; it must remain open as a creative hope for man. ◇

The future cannot be closed; it must remain open as a creative hope for man.

Welcoming Speech at "Islam: A Spiritual Message and a Quest for Justice," Rothko Chapel Colloquium IV

October 21–25, 1981

Your Royal Highnesses
Mr. President, Excellencies
Distinguished participants and guests
Friends of the Rothko Chapel

It is a joy for me to welcome you today. I do it on behalf of the board and all of those who have adopted the Rothko Chapel, all of those who come here to meditate or just sit and get away from pressure, from sorrow.

I welcome you on behalf of all of those who find here peace, joy, faith.

This place is a haven for many. People who come here like the silence, the lack of interference. They feel they can be themselves, with their grief, their struggle, their spiritual adventure, their secret exaltation.

There is still more here—consciously or unconsciously people come because they sense, they know, this is a sacred place.

Indeed it is.

The Rothko Chapel was solemnly dedicated as a sacred place ten years and ten months ago by Jews, Christians, and Muslims. The ceremony did not take place in an indifferent building. It blessed and crowned the major work of a mature artist. Mark Rothko worked, fought, despaired, worked again, and finally produced this amazing ensemble of fourteen dark panels.

Though no subject matter, no content, can be ascribed to these paintings, their majestic appearance and the spiritual impact they have on so many clearly show that there is more here than the

resolution of an artistic problem, more than a color scheme or a play of nuances.

Rothko achieved something quite exceptional. In a clearly defined and limited space, he ushered in the unlimited. Within a classical, rational structure, he introduced a nocturnal presence and all the mystery and irrationality that night implies. His dark monochrome paintings are like openings into the infinite. Their deep velvety blacks and purples do not stop the gaze. They seem to greet us with visual silence. They bring us onto the threshold of the unfathomable, the unfathomable mystery of the cosmos, the unfathomable mystery of God.

This gift to the world by a great artist has influenced people who come here. They, in turn, are responsible for the moral personality that the Rothko Chapel has slowly acquired during the ten years of its existence. There is a secret dialogue between the paintings and what we dare call the vocation of the Rothko Chapel.

All of us who love the Chapel tend to see here a place that strips us of the superfluous, of the accessory, a place that always brings us to the essential.

Here we dare ask questions that usually only children or simple people ask.

Why are we on this planet?
What for?
Is it every man for himself, every group, every nation for itself?
Or are we called to help one another, to live in harmony with one another?

Instead of harmony and peace, we see today countries pitted against one another and armed to the teeth. We see stockpiles of nuclear bombs in such quantity that a fraction of them would be enough to extinguish all the large cities of the world.

We see a deep-seated economic crisis and experts at their wits' end, incapable of understanding what is going on and giving conflicting prescriptions.

We see a whole generation of young people unable to find work, unemployment constantly on the rise—on the other hand, we also see mountains of work that remains undone.

Worse than that: we see millions and millions of people on the brink of starvation and despair—not to mention those who actually starve.

And still worse: we see people kidnapped, tortured, killed off, or left to rot in prison because they have come to the defense of the poor. And the poor themselves are tortured and killed when they dare raise their voices and try to organize themselves to survive.

In light of such dangers, such abominations, and the fact, as it seems, we are now launched into an orbit of destruction, of annihilation, it's time to pay attention to prophets and to recall the wisdom of the religious traditions.

Some prophetic words keep coming to me from memory: *Set your mind on the kingdom of God and his justice before everything else, and all the rest will come to you as well.* Should we not give priority to such divine warning?

Shouldn't moral principles have preeminence over decisions imposed by an unregulated market economy? Should we not listen to the muffled voices of the millions and millions who live in subhuman conditions?

The crisis is of such magnitude that political and technical remedies are now insufficient—the world cannot be saved by politicians and technicians, by meetings of experts and summit conferences.

However important such means are, they remain at a human level; they give us only a horizontal view.

Today we come to realize that we need also a vertical perspective, an opening onto the transcendental. Man cannot save himself; only God can save man.

Conscious of our shortcomings, we turn to you Muslims and to all those who recognize divine priorities—we need you and we welcome you.

As hosts receiving you, we are making room for you. We will enter your space and thus become your guests.

As your guests, we shall listen to you with all our attention and all our heart, hoping that some day, through a common search and common effort with all people of goodwill, we shall together bring about a better world with the grace of God. ◊

*Man cannot save himself;
only God can save man.*

Statements at the Second Rothko Chapel Awards for Commitment to Truth and Freedom

December 10, 1986

In 1981, to celebrate its tenth anniversary, the Rothko Chapel established its Awards for Commitment to Truth and Freedom. They went to eleven individuals and to the Mothers of the Plaza de Mayo, the Argentine women who insisted on finding out what had become of their "disappeared" loved ones. All had placed truth and freedom above their comfort, above their lives.

Tonight, five years later, we are welcoming representatives of two organizations and seven individuals who also have placed truth and freedom above their comfort, their lives.

Looking back at these intervening five years, we see that we face today a more violent world, one where the value of truth is more perverted. And we are more aware today than five years ago that violence does not come only from the dispossessed, the desperate, but to a greater extent from the powerful.

We had tended to ignore such violence, but our complacency was shattered the day Archbishop Oscar Romero was assassinated. He dared to confront openly a violent power structure and he paid with his life. As time passes, his figure looms higher and higher. Joining the millions who look upon him as a saintly hero, the Rothko Chapel wishes to honor his memory by establishing the Oscar Romero Award. It goes this year to a man who was his mentor, his confidant, his friend. On learning of the Oscar Romero Award, Archbishop Desmond Tutu readily accepted our invitation to present it.

Since the Rothko Chapel Awards for Commitment to Truth and Freedom were first presented in 1981, … the world has changed, and yet it has not. In Argentina a new and courageous government has tried and sentenced at least some of those responsible for the disappearance of those children sought by the Mothers of the Plaza de Mayo. In El Salvador an elected government has come to power, yet human rights defender Roberto Cuéllar remains in exile. The dissidents Tatiana Velikanova and Balys Gajauskas are still held in labor camps in the Soviet Union. Children on the streets of Harlem face a life even more devoid of opportunity today than they did five years ago. And in South Africa every day brings more detentions, more torture, more empty words, more lies, more death.

To all the heroic people, many of them anonymous, we dedicate this ceremony. ◊

Comments at the Awarding of the Carter–Menil Human Rights Prize 1986

December 10, 1986

We are assembled tonight to express our solidarity with innumerable people of the world. People who are harassed, who are persecuted, whose lives are threatened.

Some are extremely poor and their only crime is organizing to survive.

Some cannot accept intellectual and moral oppression.

Some of them simply happen to be in the way of more powerful individuals.

And some just refuse to remain silent when others around them suffer deep injustice, imprisonment, and torture.

We are expressing our solidarity by honoring tonight a few admirable human rights fighters. They represent those innumerable people who have no voice, many of whom are no less admirable. Indeed, many of those people are constantly showing incredible courage. At great risk, they stand up … and they speak out. They have been thrown into concentration camps, killed, or are "disappeared." And we all know today what it means to "disappear."

Among such sadness, it is a joy to have with us tonight a man who has been a beacon for the oppressed of the world. Even as he occupied the highest position in the country and was daily facing mountains of problems, Jimmy Carter never stopped thinking of the persecuted of the world. And he made their cause a central facet of his administration.

I was extremely honored a year or so ago when he asked me to join him in his human rights endeavors, and it is a joy to present President Carter now. ◊

REMARKS AT THE PRESENTATION OF THE SECOND
OSCAR ROMERO AWARD

March 24, 1988

It is with joy that I welcome our eminent guests and the friends of the Rothko Chapel who are here tonight to honor Cardinal Paulo Evaristo Arns.

Yet it is also with a heavy heart that I come here. Today is the anniversary of the assassination of Monsignor Oscar Romero, the Archbishop of San Salvador, who had the courage to denounce the structures of oppression in his country.

Recently His Holiness John Paul II, in his encyclical on "The Social Concern of the Church," denounced again those structures of oppression. He called them *structures of sin* and added that they were *rooted in the personal sin of the individuals who induced them, consolidated them, or made them difficult to remove.* This supreme voice and tonight the presence of Cardinal Arns, as well as the memory of Monsignor Oscar Romero, are powerful reminders of fundamental values: justice, honesty, compassion.

These values are at the heart of Christian teaching, yet they are not the monopoly of Christians. They are universal values recognized everywhere, though not always practiced. We all have a sense of justice, of decency. We all are repelled by hypocrisy, dishonesty.

But our affairs—always pressing—cloud our perception. We tend to forget the colossal injustice existing in certain sectors of the world, where people have no way of rising above intolerable poverty and where any attempt at a change means risking death.

The cries of hungry children and the screams of the tortured go unheard, except by a few. But tonight they resound in our hearts as we are assembled in and around the Rothko Chapel.

The Rothko Chapel was dedicated seventeen years ago as a sacred place where people coming from all horizons could pray and meet in search of love, truth, justice, and freedom.

The search for truth is difficult. It demands that we do not exclude ourselves from criticism and that we recognize honestly that we, too, directly or indirectly, are supporting the structures of oppression.

It takes courage and intelligence. The presence of Cardinal Arns challenges not only our courage but also our intelligence, our creativity.

This calls to mind the remarkable words pronounced by Pope Paul VI in New York City in October 1965. Talking in front of the General Assembly of the United Nations, he said, *We must get used to new ways of thinking of man, and to new ways of thinking of the community of men.* Indeed we must get used to new ways of thinking, and we are grateful to those who, like Cardinal Arns, labor in that direction. ◊

Talk at the Rothko Symposium, Yale University Art Gallery, Sponsored by the Yale Institute of Sacred Music, Worship and the Arts

December 1–3, 1989

The history of the Rothko Chapel has been related by Susan J. Barnes in her excellent book *The Rothko Chapel: An Act of Faith*, and it would be repetitive to narrate it again. I wish to emphasize that the Rothko Chapel was *not* planned. It was the consequence of unforeseen developments, and the result of John de Menil's uncompromising commitment to greatness. Undoubtedly, also, the influence of Father Marie-Alain Couturier played a major role. It is *just* that a large place be given him at this symposium.

Yet, fundamentally, the Rothko Chapel exists because Mark Rothko dreamt of such a place. It was the natural outcome of his ambition as a painter. He was a giant, inhabited by vast designs and tumultuous emotions; he longed to expand his medium by creating total environments. An opera would express better than a single voice his deep and complex aspirations.

Opportunities to create an ensemble are rare for a painter. The commission by Philip Johnson for the Seagram Building [paintings] in New York was such an opportunity, and Rothko accepted it with joy. He worked hard on the project. When the paintings were ready to be installed, he became aware that this major work of his would be placed in the building's Four Seasons Restaurant, serving as "merely a decorative backdrop for the tastes and transactions of a society he abhorred," to quote Susan Barnes, and he refused to deliver the paintings.

The decision was heroic. His paintings were not selling well, and he could ill afford the financial loss. Possibly it meant also losing his only chance to ever create an environmental work.

The paintings remained in his studio on the Bowery for a while. Then a friend of Rothko's, Douglas MacAgy, alerted us to their existence, hoping we might acquire them for a future chapel at the University of St. Thomas. We went to see them, my husband and I, and we had a sense of awe, what one feels when entering Chartres Cathedral or the Lascaux Cave. But fitting architecture to the large, irregular paintings did not seem appropriate. Besides, no funds were available then for a chapel, which was only a distant project.

It was the passion of John de Menil for good architecture that had involved us in the University of St. Thomas. His advice had been sought by the Basilian Fathers, who run the school, for a building program supported by federal funds. John de Menil offered help, provided that the architect be of international reputation. The Fathers selected Philip Johnson. A link was thus established between the university and us. One thing leading to another, we became more and more engaged in the development of the university.

In the late 1950s, we founded a small art department with Jermayne MacAgy, ex-wife of Douglas. She was a popular teacher and a brilliant lecturer, and she had the rare talent of making fascinating exhibitions on small budgets. An art department building with an exhibition gallery was planned. Her death in February 1964 put an end to this dream. A sense of immense loss overwhelmed me. One day a thought crossed my mind: When the floor collapses, it's time to make an act of faith, and this is how we decided to build the university chapel that the Basilian Fathers

wished for so much. The offer was made to the president of the university, and it was met with joyful acceptance. Johnson would be the architect, and Rothko would be asked to create an ensemble of paintings. The visit to Rothko's studio obviously played a part in the latter decision, but unconsciously we were influenced by Father Marie-Alain Couturier's strong conviction that only masters should be considered for church commissions.

In retrospect, the existence of the Rothko Chapel appears a miracle. But miracles happen only when and where there is passion, and there was passion in the making of the Rothko Chapel. There was the passion of John de Menil, ready to surmount any obstacle and to go along with a great master artist, and there was the passion of Rothko, who agonized over the work and extended himself beyond what he thought possible for him, as he wrote to us.

Rothko's paintings invite us to extend ourselves beyond what we think possible. When you enter the Chapel, everything seems very dark. It is night. But gradually the night recedes and it becomes predawn—a predawn followed by dawn. Many visitors have had this experience, and some have written about it. Their poetic and religious expression and their sentiment are the best homage to Mark Rothko. ◊

When you enter the Chapel, everything seems very dark. It is night. But gradually the night recedes and it becomes predawn—a predawn followed by dawn.

REMARKS AT THE CEREMONY FOR THE THIRD
OSCAR ROMERO AWARD, WASHINGTON, D.C.

April 24, 1990

The Rothko Chapel came into being twenty years ago out of a need and a hunger for such a place. It was the dream of a religious place of beauty that would be hospitable to all.

The great painter Mark Rothko gave reality to this dream. He was himself inhabited by a dream. He wanted to create a group of paintings that would express the poignancy of the human condition. He did. He painted for the Chapel an exceptional ensemble of dark purplish panels. In this environment many people find peace, and some become attuned to the invisible, to the supernatural, to God.

Since its consecration in 1971, the Rothko Chapel has been dedicated to both contemplation and action. Quite naturally this vocation blossomed into human rights activity, and in 1981 awards for a heroic commitment to truth and freedom were presented to twelve organizations and individuals. They included the Mothers of the Plaza de Mayo in Argentina, an American Indian chief, and a South African journalist, as well as a Lithuanian activist and a Muscovite woman, both in Siberian camps at the time. Six more awards were given in 1986.

The human rights situation in Central and South America has been of such concern to the Rothko Chapel that in 1986 the Oscar Romero Award was instituted to further voice that concern.

There is much more to say about the Rothko Chapel, but I wish to be brief because in a little while many of us will leave this room to join the crowd assembling under the dome in remembrance of the Holocaust.

The Holocaust was the most gigantic, the most heinous crime committed in our time by one section of humanity against another.

By honestly assessing the past, we can achieve peace. Peace and joy can prevail whenever there is true confession and repentance.

But while we repent abominable crimes of the past, are we not lending a hand to new crimes elsewhere and once again contributing to agony and despair?

I say "we" because we are all responsible for the culture, the patterns, and the ideologies we absorb and retransmit without correcting what is evil in them. The responsibility for the Holocaust is not limited to the Nazis. The western world and the Christian world share the responsibility. For centuries the behavior of Christians toward Jews was hostile and merciless.

By the same token, we are all responsible for the crimes perpetrated in El Salvador or anywhere in the world where we provide money and arms in support of violence. We cannot ignore the fact that in El Salvador the great majority of people are extremely poor and live in fear. They are targeted for death as soon as they organize themselves to try to better their lot. Large numbers are killed each year.

Monsignor Oscar Romero had the courage to speak out, and he was assassinated. This was ten years ago. We are told that the country has become "democratic," yet the power structure remains the same: the military is the supreme authority in the country. Violence begets counterviolence, and the vicious cycle has no

end. I am told that killings, of which civilians are the large majority of victims, amounted to 74,000 in the last ten years. It is as if, in the United States, 30,000 people had been killed every month for the last ten years.

But let those who know talk, and let Bishop Medardo Gómez and María Julia Hernández bring their testimony. ◊

… we are all responsible for the culture, the patterns, and the ideologies we absorb and retransmit without correcting what is evil in them.

Comments at the Awarding of the Carter–Menil Human Rights Prize 1990

December 10, 1990

I agree 100 percent with what President Jimmy Carter says, except what he says about me.

I was very moved and honored when President Carter contacted me some years ago, and I became enthusiastic about what he was telling me about The Carter Center; I could visualize what such a place could become. His profound commitment to human rights is well known by everyone and has been mentioned, so I won't dwell on it.

President Carter had heard of the Rothko Chapel and of our modest efforts to promote human rights by recognizing exceptional people who, at risk of their lives, fight injustice and oppression. We thought we should join efforts, and on March 17, 1986, the Carter–Menil Human Rights Foundation was established. At that time it was decided that there would be an annual award that would be presented to such heroic people or to the organizations that they animate. The same year, on December 10, the first Carter–Menil Human Rights Prize was presented in Houston in a joint ceremony with the Rothko Chapel Awards for Commitment to Truth and Freedom. Next year we will again be in Houston, on the occasion of the twentieth anniversary of the Rothko Chapel, and we will have joint awards once more from both organizations. By giving those awards, we want not only to recognize and honor the admirable people who fight so courageously for their brothers and sisters in search of the most elementary and indispensable justice, but also to support their efforts.

The struggle for human rights must be at the forefront of all that we do. We who enjoy freedom cannot accept that millions of

people awake daily to suffering, to hopelessness, to deadly fear. President Carter, please join me in presenting the 1990 Carter–Menil Human Rights Prize to the Consejo de Comunidades Etnicas Runujel Junam of Guatemala and to the Civil Rights Movement of Sri Lanka. ◇

We who enjoy freedom cannot accept that millions of people awake daily to suffering, to hopelessness, to deadly fear.

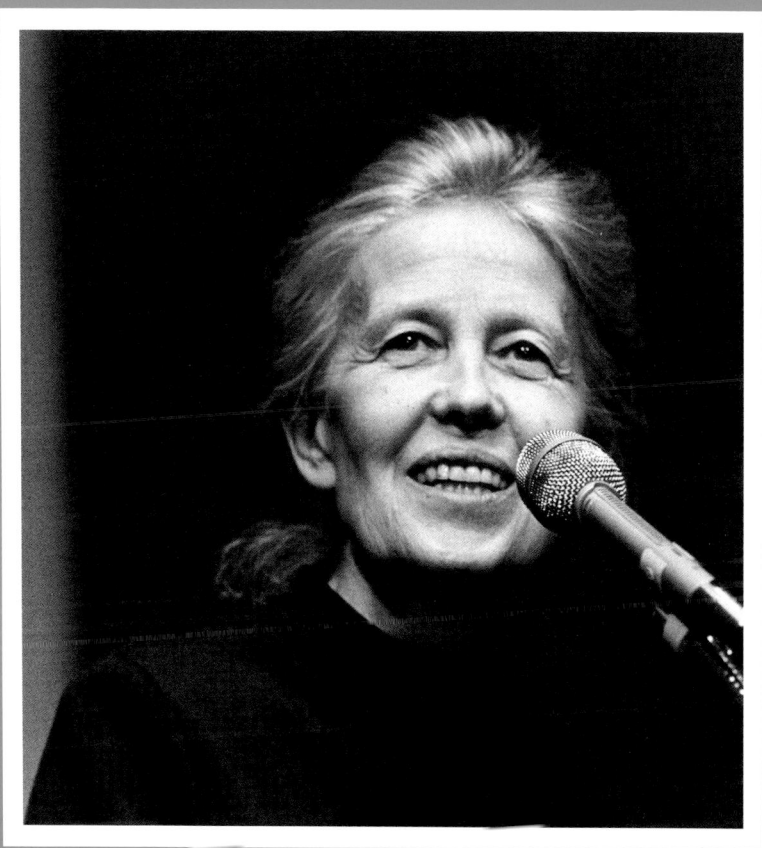

Dominique de Menil, 1976

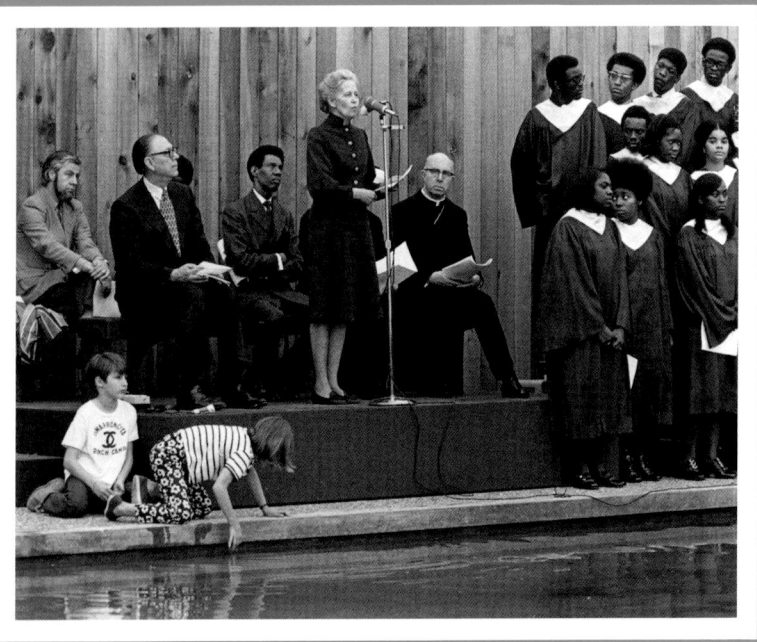

Dedication of the *Broken Obelisk*, February 28, 1971

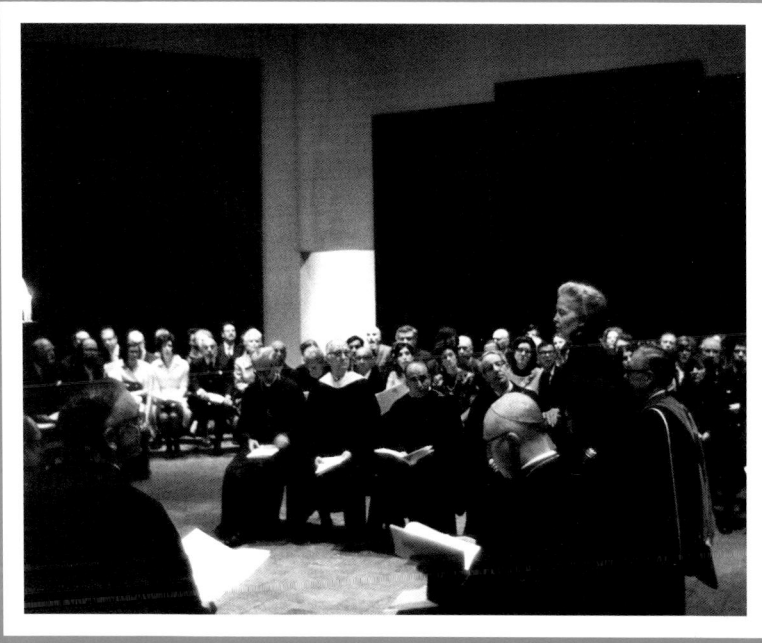

Inaugural Address, February 27, 1971

Rose Styron and Dominique de Menil, Rothko Chapel
Awards to Commitment to Truth and Freedom, June 1981

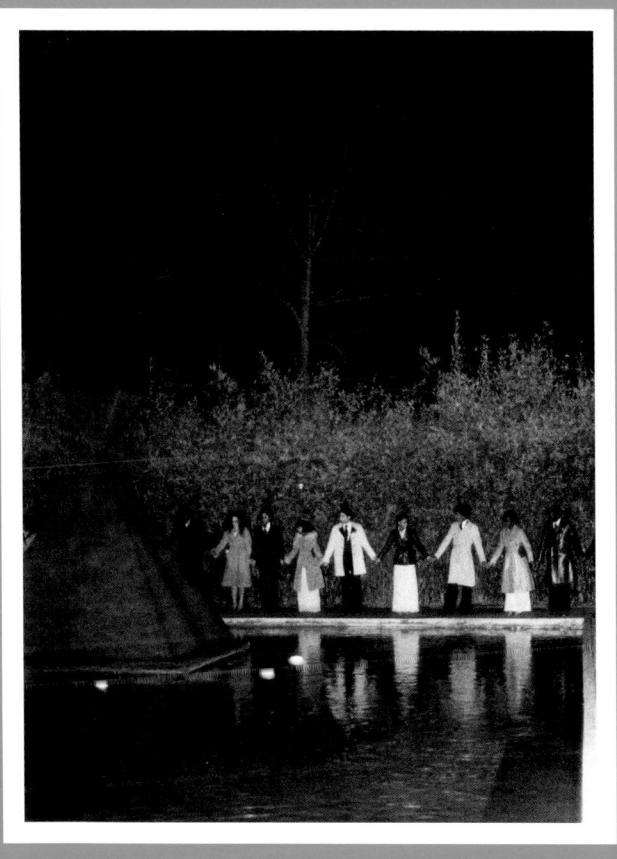

Annual Birthday Celebration honoring
Dr. Martin Luther King, Jr.

It should remind us over and over again that there is no love without justice.

Dominique de Menil and religious leaders, February 1971

Dominique de Menil, Raimon Panikkar, Colloquim I, 1973

John de Menil, 1971

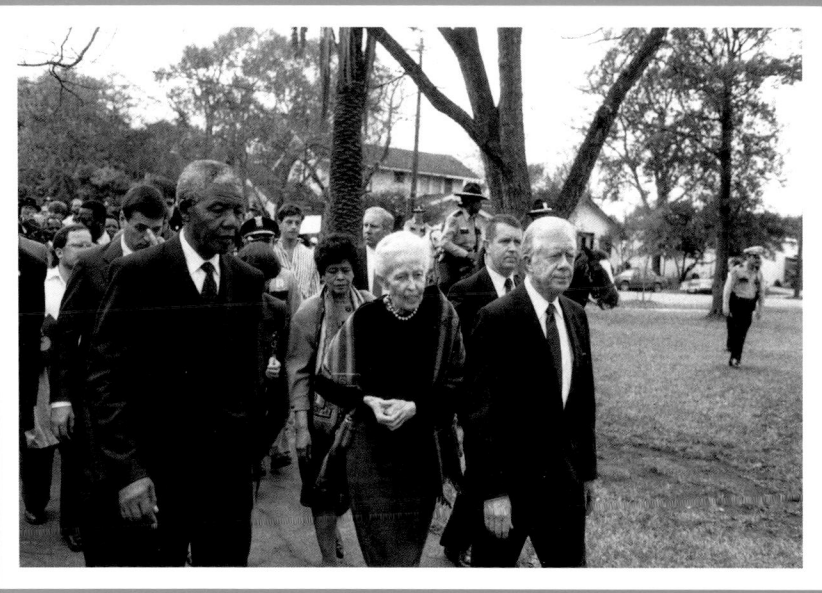

NELSON MANDELA, DOMINIQUE DE MENIL AND PRESIDENT JIMMY CARTER, DECEMBER 1991

We live in dramatic times.

Violent confrontations are erupting in all parts of the world.

Instinctively we feel that it does not have to be so.

That confrontation could give way to cooperation.

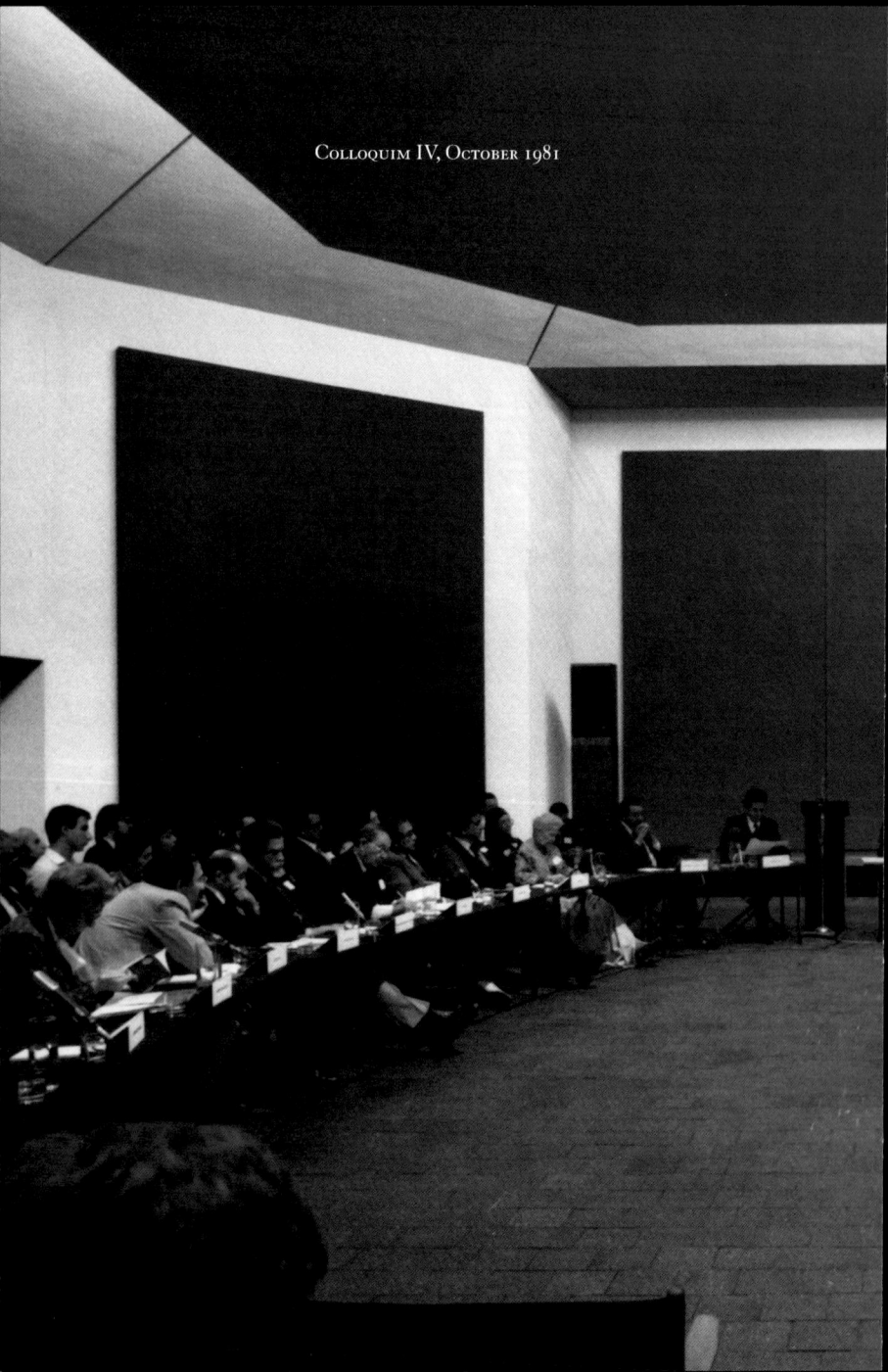
Colloquim IV, October 1981

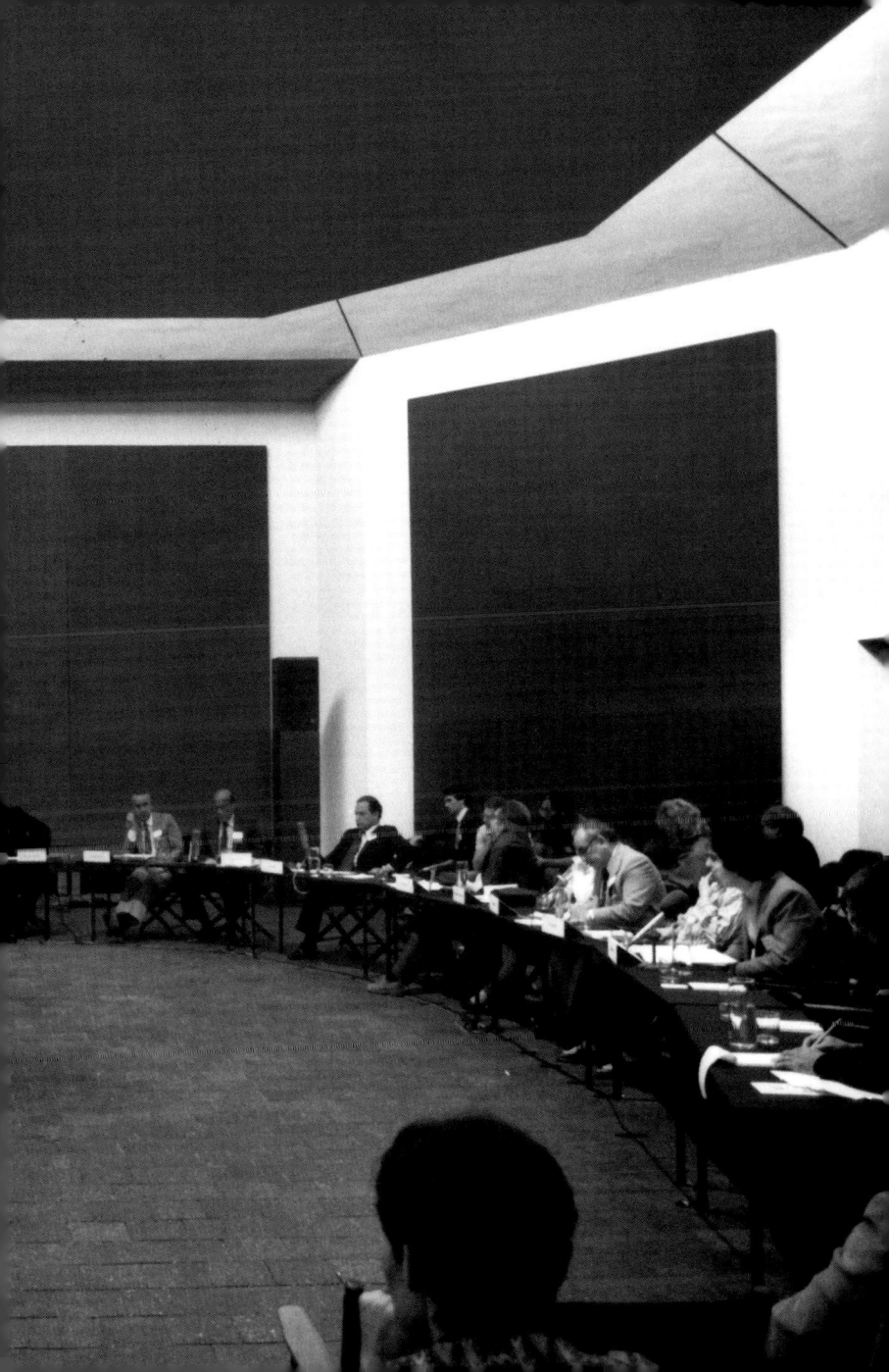

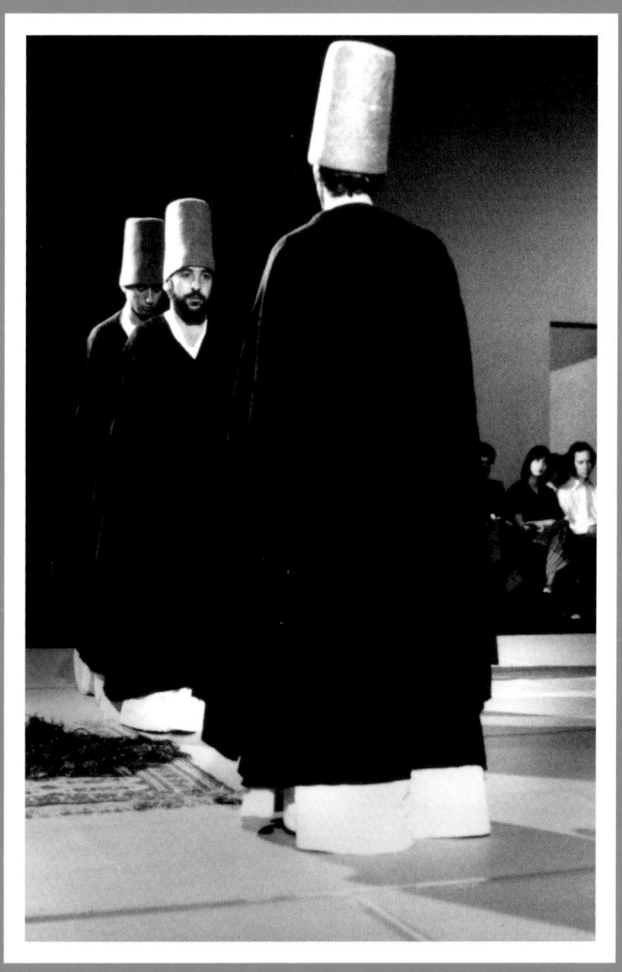

WHIRLING DERVISHES, 1978

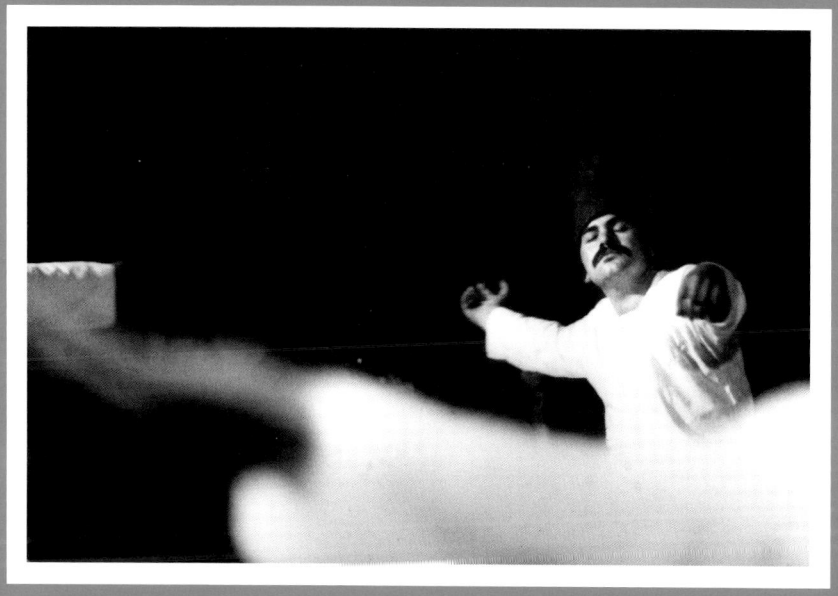

You have brought to us in a most beautiful way the message of Mevlana: a message of love and joy, a message of universal brotherhood.

Steve Reich, December 1981

Rothko Chapel Awards to Commitment to
Truth and Freedom, 1981

Dominique de Menil and Najmuddin Bammat, Colloquium IV, October 1981

Dominique de Menil, October 1981

Pandit Pra Nath, Morning Ragas, 1981

LaMonte Young, Pandit Pra Nath, Marianne Zazeela, 1981

A Time of Prayer, 1978

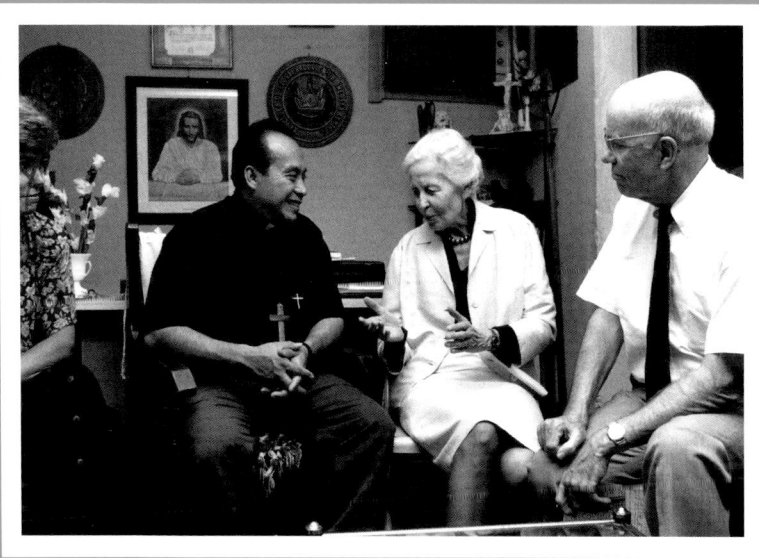

Bishop Medardo Gomez, Dominique de Menil,
Ambassador Donald Easum in El Salvador, 1990

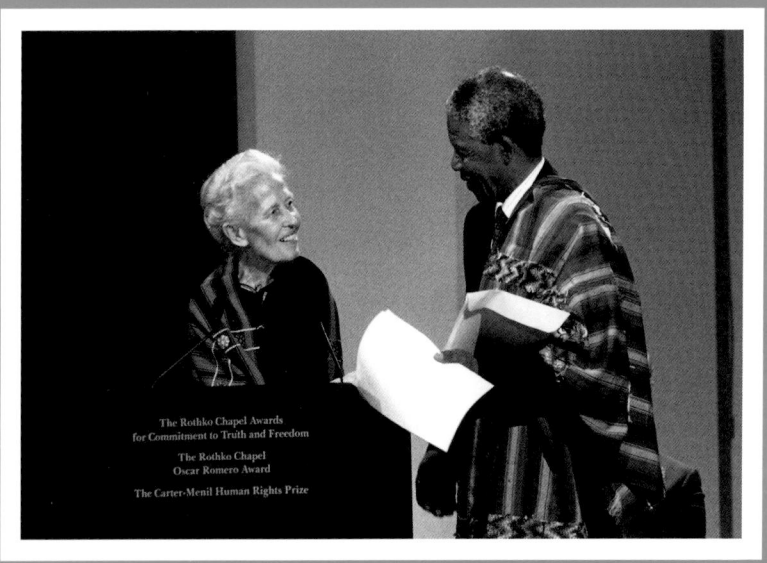

Dominique de Menil and Nelson Mandela, December 1986

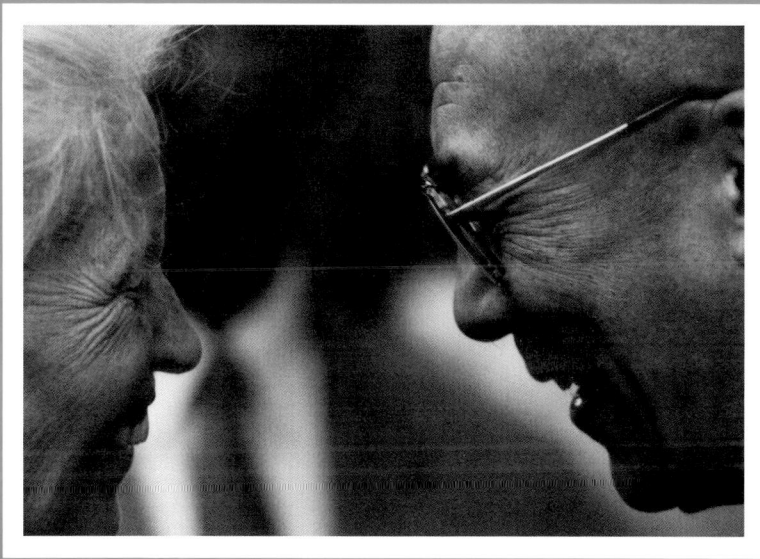

Dominique de Menil and the Dalai Lama, 1991

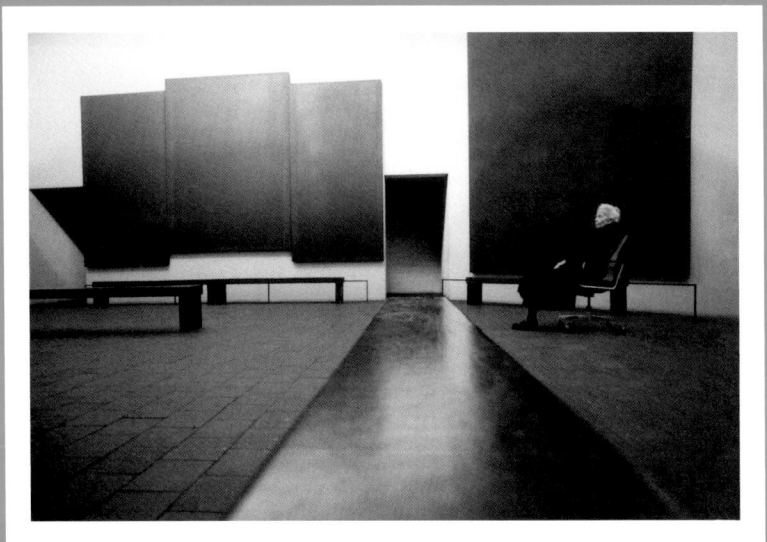

Dominique de Menil, 1997

*The world is not a peaceable kingdom.
Indeed, strength is needed. But strength to unite with one another
or else the world will disunite. Strength to integrate our efforts
or else the world will disintegrate.*

Opening Remarks at "Christianity and Churches on the Eve of the Vatican II," Rothko Chapel Colloquium VI

January 12–15, 1991

Dear Bishop Fiorenza, dear Dom Helder, dear participants and friends.

It is a joy to welcome you here, though circumstances have it that this conference takes place at a most tragic time, when the Middle East might soon burst into flames. This awful prospect casts a dark shadow over humanity, yet it should not deter our resolution to go on with the conference.

The Rothko Chapel is twenty years old—almost. On February 27, 1971, eminent dignitaries of the Catholic and Orthodox Churches and of the World Council of Churches, as well as representatives of the Jewish and Islamic faiths, solemnly dedicated the Chapel as a sacred place open to all religious traditions. Not to mix them—quite the contrary—but to learn about the other traditions, to learn to respect and love them.

Mark Rothko, the artist who created this environment, masterfully responded to this ambitious goal. So masterfully that the fame of the Chapel has kept growing during those twenty years, and people from all over the world now come here to visit and pray.

In a way, nothing could be more appropriate on this anniversary of the Rothko Chapel than to open the doors to a conference on Vatican II. Vatican II was an extraordinary event, not only for Catholics, not only for Christians at large, but for mankind. It was an unprecedented effort of religious rededication. With humility, as well as with authority, the Catholic Church reoriented itself to greater fidelity in the pursuit of its mission. The sincerity of the move and the commitment to reach the world with greater love and understanding were such that it resounded everywhere. At the

death of Pope John XXIII, grief was universal, as though a common father had died. A glimmer of hope had been perceived on the horizon: the hope for the universal brotherhood to which we all aspire.

We cannot forget that hope, and we must keep working to preserve such a heavenly gift. We are grateful to all of you who are contributing so much to that enterprise. We salute the Istituto per le Scienze Religiose of Bologna, which is dedicated to gathering and researching documents on Pope John and his message, and which has organized this conference. We wish to express special thanks to those of you who have come from afar to join in the work of deepening the understanding of a precious legacy: Vatican II. ◊

Remarks at a Dinner Honoring Nelson Mandela and Introducing Recipients of the 1991 Carter–Menil Human Rights Prize

December 7, 1991

I would like to salute Nelson Mandela on behalf of all of us here tonight, and also on behalf of the many friends of The Carter Center and of the Rothko Chapel throughout the world—friends known and unknown who all have a common faith in the fundamental goodwill and goodness of humankind.

We live in dramatic times. Violent confrontations are erupting in all parts of the world. Instinctively we feel that it does not have to be so. That confrontation could give way to cooperation. In his firm and quiet way, Mr. Mandela tells us that it is possible.

Mr. Mandela shows us that we can be strong and yet have an optimistic and open attitude.

The world is not a peaceable kingdom. Indeed, strength is needed. But strength to unite with one another or else the world will disunite. Strength to integrate our efforts or else the world will disintegrate.

Apartheid makes life unlivable for black Africans. It has been condemned by the United Nations and by nations individually. In his fight against apartheid, Nelson Mandela endured twenty-seven years of prison without letting bitterness enter into his heart and obscure his judgment.

This noble attitude gives us the conviction that the force of justice and the power of goodness bear fruit.

It gives us the conviction that what is best in us will prevail. ◊

A Statement

1991

On February 26, 1971, the Rothko Chapel was consecrated to God—a sacred place open to all—by eminent representatives from the Vatican, the Orthodox Church of North and South America, and the World Council of Churches, and by eminent practitioners of the Jewish and Muslim faiths—rabbis and scholars.

During the twenty years of its existence, the Rothko Chapel has plodded along, humbly trying to uphold a double vocation:

a vocation of hospitality to both individuals and groups in need of a sacred place where the dignity of all is recognized; and

a vocation of combat, denouncing all forms of imperialism, whether political, economic, social, or intellectual.

This year we are happy to join forces with former President Jimmy Carter, whose indefatigable fight against poverty, disease, and human rights abuses has been heralded throughout the world. Considering his equal dedication to helping young and troubled nations achieve democratic maturity, he is the ideal companion with our governor, Ann Richards, and our mayor, Kathy Whitmire, to greet along with us Nelson Mandela, a hero of democratic struggle, a living symbol of human resistance to injustice and oppression.

Together with these two great men, our governor, and our mayor, the board of the Rothko Chapel is welcoming two brothers of the six murdered Jesuits posthumously honored today by the Carter–Menil Human Rights Foundation—Father Francisco Estrada, rector of the University of Central America, and Father

Charles Beirne, vice rector—along with nine recipients of the Rothko Chapel Awards for Commitment to Truth and Freedom. At great risk these remarkable men and women have placed their moral responsibility ahead of their lives. They have totally committed themselves to the defense of justice, truth, and freedom. ◊

During the twenty years of its existence, the Rothko Chapel has plodded along, humbly trying to uphold a double vocation:
- *a vocation of hospitality to both individuals and groups in need of a sacred place where the dignity of all is recognized;*
- *and*
- *a vocation of combat, denouncing all forms of imperialism, whether political, economic, social, or intellectual.*

Acceptance Speech on the Occasion of Receiving the
1992 Christian Culture Series Gold Medal Award from
Assumption University, Windsor, Ontario, Canada

March 8, 1992

There would be no Rothko Chapel if Mark Rothko had not existed.

Rothko was a Russian Jew, deeply motivated by his faith. His mother had been a pious woman, and as a child, he himself had been very religious.

I do not want to attribute to Rothko beliefs he did not have or professed not to have. But Jews cannot escape being the "chosen people" of God. Nobody can take that destiny away from them—not even they themselves.

Jews sometimes prophesize. Not in a literal sense, but in their thinking and writing. They are often visionaries. Rothko was a Jewish prophet.

He chose to express his deep feelings with painting. He was inhabited by the poignancy of the human condition, by the brevity of life. He was in search of the absolute.

In the spring of 1964, my husband and I offered Rothko the opportunity to create paintings for a chapel. Right away he said, yes, he would do it. It was as if he had been waiting for such an opportunity, and indeed he had. He had reached the limit of what he could do with single paintings. He wanted to expand his vision and combine a number of paintings, relating each one to all the others.

He told me that when he started to work, he would not call. He would go through doubts, agonizing doubts. He would work, stop working, work again, and would not communicate with us during that time. He would call only when he emerged from the tunnel.

He became a recluse. He worked with one, then two assistants, stretching huge canvases, painting them, placing them on the mocked-up scaffolding, then discarding them and painting new

ones. At times he just sat in front of his paintings, looking at them, brooding, thinking, while listening to recordings of Bach or Mozart.

One day, finally, he called me and he showed me one painting. I was taken aback. It was a very large canvas of a dark purplish color, much darker than anything I had anticipated. He did not say a word. I did not say a word. I sat and looked, and he looked at me. Gradually I began to absorb, or rather I was absorbed into, an ocean of soft, velvety, purplish-black.

When, at last, the paintings were installed in the Chapel, it became clear that Rothko had won his heroic combat. He had created a chef-d'oeuvre, poignant and subtle.

Rothko had accepted the frightening void facing him. He had taken the risk of a leap in the dark because he believed he could express with his art the plenitude he felt in himself. And this plenitude had been recovered by his art.

Like every creator, he had passed through death to resurrection.

Visitors, too, are confronted by a process of death and resurrection. The Chapel paintings are like icons. What is represented on the icon is not there—yet it is there.

The Rothko Chapel signals a beyond. The genius of Rothko is to have created a space where dawn is already present in the night. It is predawn.

Many instinctively have felt the great achievement of Rothko. They have experienced the peace of the night and the exultation of the coming dawn.

First it was people in the neighborhood who came. They adopted the Rothko Chapel at once as a sacred place. They came to pray and meditate.

Gradually the world learned about this new sacred place, and people came from everywhere. Many made the journey to Houston only to see the Rothko Chapel.

And many of those passersby leave a trace of their passage in the visitor's book. Their remarks, often terse, are original and profound.

Someone wrote in 1983:
A loud calm and an unending sense of being, and beyond.

Another visitor wrote in 1986:
An extraordinary Chapel. It brings me to the beginning and end, to the essence of life.

And:
A mantle of peace seems to drop on your shoulders.

The Rothko Chapel induces spiritual ascents, aspirations to light beyond the night, calls to unity, to brotherhood.

Other pilgrims have written:
Here I feel a citizen of the world.

And:
[I feel] as if I am part of a collective breath.

But what is the Rothko Chapel? It is a legacy of Rothko's ... and more.

More because the Chapel was officially opened and consecrated to God on February 27, 1971, by eminent representatives of the Orthodox and the Roman Catholic Church, by rabbis and Muslims.

It has been spontaneously adopted by people of all traditions and all countries, who thus confirm its vocation of hospitality. The Chapel is open to all, and each visiting group follows and deepens its own tradition, enriching and being enriched by other traditions.

A colloquium "Traditional Modes of Contemplation and Action in World Religions," held in July 1973, acted as its founding charter. It set the stage for future ecumenical activities.

"Contemplation" and "action" remain the keywords of the Chapel's life.

Action has been focused on human rights. It was Dom Hélder Câmara, a friend of the Rothko Chapel from the start, who urged us to observe the December 10th anniversary of the United Nations Universal Declaration of Human Rights.

Starting in 1973, every December has brought to the Rothko Chapel an event manifesting the cause of human rights. The program took a momentous turn in 1981 when it was decided to celebrate the tenth anniversary of the Chapel by presenting the first Rothko Chapel Awards for Commitment to Truth and Freedom to twelve people or organizations. Among them were the Mothers of the Plaza de Mayo, Argentina; two prisoners in Soviet labor camps; a South African journalist; and a young Salvadoran lawyer who had worked closely with Archbishop Oscar Romero.

In 1986 the Rothko Chapel marked its fifteenth anniversary by presenting the second Rothko Chapel Awards for Commitment to Truth and Freedom. Recipients included Charter 77, the Czechoslovakian underground organization founded by Václav Havel; two South African women, Albertina Sisulu and Helen Joseph, one black, one white; Anatoly Koryagin, the Soviet doctor who had dared to oppose internment of political prisoners in psychiatric hospitals; and two lawyers from the Occupied West Bank; as well as the American Sanctuary organization that shelters, through an underground network, Central American refugees facing deportation.

It was a joint ceremony with the newly founded Carter–Menil Human Rights Foundation that brought to the Chapel former President Jimmy Carter, Archbishop Desmond Tutu as the keynote speaker, and Yuri Orlov, the famous Russian dissident, who had been released only two days before from a Russian gulag. Yuri Orlov had been in the same forced labor camp as Anatoly Koryagin. He told us how Koryagin, a much younger man, had saved his life by doing Orlov's daily quota of work as well as his own.

Last December 8, to celebrate the twentieth anniversary of the Rothko Chapel, we again joined forces with the Carter–Menil Human Rights Foundation. We decided that both institutions would focus on Central America.

It was an extraordinary event where sadness abounded, yet joy exceeded sorrow.

The Carter–Menil Human Rights Prize was awarded posthumously to the six Jesuits murdered in November 1989.

As one recipient said, *In a society in which the most basic human rights of the majority are structurally and systematically denied,... the fathers of the Jesuit University had been the most eloquent and effective proponents of a peaceful society.*

The actual presence of men and women who had fought under death threats, some enduring torture, and who came to the Chapel with their hopes and their goodwill brought us a moment of intense communion.

Nelson Mandela was also with us as our keynote speaker. After twenty-seven years in prison, he had remained strong and noble. He shared with us some of his strength, and we experienced with him the joy of brotherhood. Because we were together, we truly existed as human beings.

The great figure of Archbishop Oscar Romero was present, too, through Bishop Rodolfo Quezada Toruño, who came to receive the fourth Rothko Chapel Oscar Romero Award. Bishop Quezada, with infinite patience and intelligence, is working to achieve peace in Guatemala.

A particularly moving moment was the appearance of the twenty-one-year-old María Mirtala López of El Salvador. At age twelve she witnessed the torture and murder of her entire family, and fled to the hills. At fifteen she took refuge in a church, and learned to read and write. With other refugees she later helped form the Christian Community of the Displaced of El Salvador.

We were also deeply moved by the young Indian peasant from the highlands of Guatemala, Sebastian Suy Perebal. After four human rights activists had been murdered in his village, while

others were seriously wounded or fled, he remained as the local leader of the Grupo de Apoyo Mútuo, still in imminent danger, yet unwavering in his commitment.

Someone I will never forget is the journalist from Colombia, Ignacio Gómez. He and the editor of the daily newspaper *El Spectador* were actively involved in exposing drug trafficking. Since they began, two reporters, five assistants, a lawyer, and distribution agents of the journal were killed, three editors were kidnapped, and printing facilities were destroyed.

As he departed, he said to me, *I want you to know what an incredible weight has been lifted from our shoulders.*

The people we wanted to help and honor in reality honored us a thousand times more. Governor Ann Richards found the right words when she acknowledged them as missionaries of the spirit. ◊

Unpublished Opinion, "We Should Not Forget and Must Not Remain Silent"

November 1993

As winter sets in and we approach the warmth of our holiday season, I am compelled to think of Bosnia. Sarajevo is still under siege and no one seems to feel an urgency to save it.

Every other year since 1986, the Rothko Chapel has presented the Oscar Romero Award to people or institutions who have risked much—even life itself to preserve human rights in their countries. When scanning the world for the appropriate person or organization to receive the 1993 award, we held fast to our objectives: to support truth and freedom, and to support men and women in countries where greed, violence, and power transgress human rights and human values. It became crucial and imperative to give our attention to the former Yugoslavia.

There, a community lived in balance and harmony, and could be considered a model of human relations among people of different ethnicities and religions. This example in Sarajevo of successful pluralism, this *modus vivendi*, illustrated the advantages of an integrated society. It negated totalitarian and sectarian extremism. But much more important was the fact that the people of Bosnia wanted to live together and refused so-called ethnic partition.

On June 16, in conjunction with the United Nations World Conference on Human Rights held in Vienna, the Rothko Chapel presented its Oscar Romero Award to *Oslobodjenje (Liberation)*, the multiethnic, multi-religious newspaper of Sarajevo. Its staff, at great sacrifice and enormous risk to their lives (two killed, seventeen injured at that time), kept on printing and distributing a paper that not only informed the people of Sarajevo about what was happening to their country and government, but also represented

the spirit of resistance and the freedom of a city that had refused to become a conglomeration of ghettos.

Today I met Kemal Kurspahi, the editor-in-chief and proprietor of O*slobodjenje*. This meeting brought back the feeling of inadequacy and helplessness that we all experienced listening to deputy editor Gordana Knezevi's acceptance speech at the award ceremony in Vienna.

In our meeting with Mr. Kurspahi, aware that our silence could be construed as complicity with the injustice inflicted on the people of Bosnia, I asked him: What can we do? His response was that help could come only from people in a position of power, those who could threaten the aggressors and use their authority and influence to find an equitable solution. He feels, like most Bosnians do, betrayed and abandoned to die at the hands of the aggressors and supporters of ethnic cleansing and ethnic partition,

Whether it is an immediate death through bombing and sniping or a slow death through siege, the multiethnic community of Bosnia, particularly that of Sarajevo, is going to die if the great powers keep searching for a conciliatory solution to appease and please the aggressors at the expense of the aggressed.

The conversation was very informative but heartbreaking. It revealed the loss of hope of the Bosnians and their resignation to die in dignity while the others who could offer help, the United Nations and the great powers, are more concerned with their immediate interests of security and domestic politics.

In Bosnia humanity is at stake. There are moments when every one of us must take a stand and assume responsibility. At the Rothko Chapel in December 1991, Nelson Mandela said:

Our common humanity transcends the oceans and all national boundaries. It binds us together to unite in a common cause against tyranny, to act together in defense of our very humanity.

We have a moral responsibility to our fellow men and women in the former Yugoslavia: we cannot forget and we cannot remain silent. ◊

Remarks at the Ceremony for the Fifth Oscar Romero Award, Vienna, Austria

June 16, 1993

I am supposed to make a few remarks. I would rather remain silent. So much has been said about the atrocities in Bosnia-Herzegovina, and so little has been done. Talking sounds almost offensive.

Great people have made passionate declarations calling for immediate interventions. But these were like flashes in the night. Those who denounced the horrors perpetrated against the Muslims had not the power to act. And those who had the power to act did not. Military action was said to be unrealistic, extremely dangerous, and anyhow public opinion both in Europe and in America was against intervention.

Thus ethnic cleansing goes on. Ethnic cleansing is somewhat of a misnomer. Serbs, Croats, and "Muslims" are all ethnically related. They all belong to a branch of the Slavonic race, and they all speak Serbo-Croat. But due to complex historical circumstances, they each developed different cultural identities referred to as "ethnicities."

The failure of the international community to stop the butchery of civilians in Bosnia is appalling, and it starts a train of thought.

If powerful armies, the wisdom of experts, the debate of great nations' politicians, and the work and dedication of the United Nations have not succeeded in stopping the massacres we have witnessed on our TV screens, should we not make a radical reassessment?

Already in October 1965, when Pope Paul VI, responding to the invitation of U Thant, came to the United Nations in New

York, he warned that peace is not built only with politics and balance of forces and interests, but with the spirit, the ideas, and the works of peace.

Speaking for the Catholic family and for his Christian brothers, he said that he had a message to deliver—the message of love they had received almost two thousand years ago.

The Pope spoke of the search for dialogue with all the world. He came, he said, as an expert in humanity, to offer moral ratification to this political institution.

He rejoiced at the existence of the United Nations. It should be congratulated and encouraged. It should never be allowed to fail. It had to be perfected and adapted to the demands that history will present. *Impossible to go back,* he said. *Forward is the only way.*

This was twenty-eight years ago. The Pope's warning that peace cannot be built only through politics and balance of forces and interests has become a tragic reality. Should we not then question the benefits of "realpolitik" and the wisdom of self-interest? Should we not consider the deep message of Paul VI?

From ancient days we can hear voices addressing the conscience of men, the voices of prophets. They appeal to a higher order of life. They talk about divinity, about love and unity.

At times these ancient voices have been misunderstood. They have become instruments of oppression by some who profess to observe their message.

At times the message of the voices has been misused and counterfeited. Religious sects have cropped up here and there

whose leaders pretend to bring a message of love but only exalt themselves and force their members into abject submission.

In spite of such perversion and confusion, the voices keep inspiring the hearts of many who profess no beliefs: atheists, agnostics, free thinkers.

These unbelievers do the work of the spirit, simply, indefatigably, and at times heroically. They have love in their hearts, and their way of thinking is not far from the advocates of peace in the great religious traditions.

To give priority to the message of the prophets requires that a mutation of the world take place. It will have to be a mutation of people, one by one, because institutions and governments are expressions of the people who back them or tolerate them—unless these people have no voice at all, as is the case today in many parts of the world.

The Oscar Romero Award of the Rothko Chapel, like all other Rothko Chapel awards, is given for truth and freedom. Truth and freedom are our guiding values. They imply justice and peace.

To get out of the abominable chaos, the hell in which citizens from ex-Yugoslavia are trapped, truth and freedom are a prerequisite. The people desperately need journalists of courage.

To become independent of the nationalist propaganda, people need to know facts and to judge objectively. So strong is the power of the media that it can turn a friend against a friend, a brother against a brother.

Josef Goebbels was a master at handling the media. With enough "savoir-faire," brains can be washed collectively within months. Only the very strong resist.

Such is the brave team of *Oslobodjenje* we are honoring:

Kemal Kurspahi – Editor-in-chief

Zlatko Dizvarevi – Executive Editor

Gordana Knezevi – Deputy Editor

Rasim Cerimagi – Political Editor

I want also to acknowledge and salute the other independent newspapers who are fighting the same combat:

Vercene Novine (Evening News) in Saravejo

Borba (Combat) in Belgrade

as well as the weeklies:

Vreme (The Times) in Belgrade

Monitor in Montenegro

Novi List in Croatia

Mladina in Slovena

Radio is also a powerful transmitter. Independent radios are:

Radio 92 in Belgrade

Radio Brod

(which means "Boat Radio" and transmits from a boat in the Adriatic)

I wish to salute also with admiration the following organizations:

The Center for Anti-War Action was founded in July 1991 in Belgrade by Vesna Pesi. I mention her name with emotion. She is a courageous and indefatigable leader who must be acknowledged.

The House of Sarajevo's Citizens is another wonderful initiative. It was opened in early 1993 by the European Assembly of Citizens. It is a blessed place where people from Sarajevo can communicate and where representatives of non-governmental organizations can meet Bosnians.

Izbor, which means Choice/Election, is a network of lawyers of all ethnicities who are defending people each from another ethnicity: a Croat defends a Serb in Croatia, and vice versa, and both Serbs and Croats defend Muslims.

The strength of such clear-minded, generous, and determined people is heart lifting. It is with such people that the future lies. I want to express to them the solidarity of people throughout the world.

The fight taking place in ex-Yugoslavia is also our fight. Humanity is at stake. Nelson Mandela expressed it so well in December 1991 when he came to Houston for another human rights event. He said: *Our common humanity transcends the oceans and all national boundaries. It binds us together to unite in a common cause against tyranny, to act together in defense of our very humanity.* ◊

Remarks at the Ceremony for the Sixth Oscar Romero Award

January 11, 1997

Only a poet can find the words to convey the silent messages coming from Algeria today.

For me it took the French poet Charles Baudelaire to find the appropriate words, when he talked about the feeble voice of a wounded soldier who has been forgotten, buried under a pile of dead bodies and remaining motionless, yet making prodigious efforts to move where he lies next to a pool of blood.

But this is not the last chapter for Algeria. Algeria can rejoice. Algeria has a great Sufi saint—Abd el Kader—a mystic in the line of Ibn Arabi. He was betrayed by France. France did not keep its word.

The conquest of Algeria by France, a complex colonial enterprise launched in May 1830 when the French fleet left Toulon for Algeria, is certainly at the origin of the present ordeal of Algeria. Later it would also have sparked a civil war in France if Charles de Gaulle, at the time president of the Republic, had not acted with decisiveness and rapidity. Four treacherous generals in Algiers had created the Organization of the Secret Army, the OAS, to take over power in France from their Algerian base. De Gaulle addressed himself by radio to all French citizens, asking them to block airports by leaving their cars on the runways, thus preventing a surprise landing of the OAS and a coup d'état taking over the power of the Republic.

Today's situation is no less atrocious.

The abusive recourse to arms and violence in Algeria, and the explosive situation thus created, has led the board of the Rothko Chapel to dedicate its 1997 Oscar Romero Award to that country.

We have with us tonight two Algerians of different generations confronting the same conflict, each in her and his own way: Salima Ghezali, editor of *La Nation*, and Abdennour Ali-Yahia, founder and president of the Algerian League for the Protection of Human Rights. ◊

In retrospect, the existence of the Rothko Chapel appears a miracle. But miracles happen only when and where there is passion, and there was passion in the making of the Rothko Chapel.

Notes

◇ The opening and dedication of the Rothko Chapel and Barnett Newman's *Broken Obelisk* took place in a series of events held on February 26, 27, and 28, 1971. The opening for dignitaries, scholars, art critics, artists, prominent Houstonians, and friends was held on February 26. The following day, February 27, the formal dedication of the Rothko Chapel to worship, meditation, and spiritual events was given by:

The Right Reverend Scott Field Baily, D.D., Secretary of the House of Bishops, Episcopal Church of the United States, Houston, Texas.

The Right Reverend Kenneth W. Copeland, S.T.D., Bishop Texas Conference, United Methodist Church, Houston, Texas;

Shukri M. el-Khatib, Ph.D., Religious Secretary, Islamic Society of Greater Houston and Research Associate, Baylor College of Medicine, Houston, Texas;

◇ R. Paul Green, Ph.D., Chairman, Division of Fine Arts, Houston Baptist University, Houston, Texas;

The Right Reverend Bishop John, Titular Bishop of Thermon, Greek Orthodox Archdiocese of North and South America, Brookline, Massachusetts;

The Reverend William Lawson, D.D., Pastor, Wheeler Avenue Baptist Church, Houston, Texas;

Rabbi David L. Lieber, Ph.D., President, University of Judaism, Los Angeles, California;

The Most Reverend Bishop John L. Markovsky, S.T.D., Coadjutor Bishop of Galveston-Houston, Houston, Texas;

◇ Professor Albert C. Outler, Ph.D., D.D., Litt.D., Professor of Theology, Perkins School of Theology, Southern Methodist University, Dallas, Texas;

Rabbi David Polish, Ph.D., Chairman, Central Conference of Rabbis, Evanston, Illinois;

Mrs. Ruthabel Rollins, Director, Concert Choir, Texas Southern University, Houston, Texas;

The Reverend Eugene S. Smith, Ph.D., D.D., Executive Secretary, World Council of Churches, U.S.A., New York, New York;

The Reverend Thompson L. Shannon, Ph.D., D.D., President, Institute of Religion and Human Development, Houston, Texas; and

His Eminence, Jan Cardinal Willebrands, President, Secretariat for the Promotion of Christian Unity, Vatican City.

From 1969 to 1972, the Rothko Chapel was under the aegis of the Institute of Religion and Human Development, an independent organization based in Houston formed by doctors and clergymen who saw the need to strengthen, within the scientific community, the connection between religion and the healing arts. The Rothko Chapel became an independent non-profit organization in October 1972.

◇ On February 28, 1971 the Rothko Chapel opened to the public at 1 p.m., and a dedication and public ceremony was held at 4 p.m. The program comprised the dedication of Barnett Newman's *Broken Obelisk* to the memory of the Reverend Doctor Martin Luther King, Jr.; a gathering hymn; an invocation by The Reverend William Lawson; a unison reading led by The Reverend Donald S. Williamson, Ph.D., Dean, Institute of Religion and Human Development; an anthem by the Texas Southern University Concert Choir; a statement by Dominique de Menil; a response by Dr. Randolph Blackwell, Director, Southern Rural Action, Inc., Atlanta, Georgia, representing Mrs. Martin Luther King, Jr.; and a final benediction by Dr. Thompson L. Shannon, President of the Institute of Religion and Human Development.

◇ Colloquium I, "Traditional Modes of Contemplation and Action in World Religions," held at the Rothko Chapel July 22-30, 1973, was organized by Yusuf Ibish, Ph.D., Professor at the American University of Beirut.

Colloquium participants were Wande Abimbola, Shojun Bando, A.K. Brohi, Esq., Joseph Epes Brown, Victor Danner, Yusuf Ibish, Toshihiko Izutsu, Archbishop Georges Khodr, Lama Lopsang P. Lhalungpa, T.M.P. Mahadevan, Seyyed Hossein Nasr, Jacob Needleman, Raimon Panikkar, Awadh Kishore Seran, Leo Schaya, André Scrima, Huston Smith, al-Sayyedah Fatima al-Yashrutiyya, and Elémire Zolla.

Musicians Jihad Abu-Mrad, Munir Bashir, Pandit Pra Nath, Daryush Safvat, and Nur al-al Din Sarvistani were present and performed during the colloquium.

In 1979, Dominique de Menil said, "The first [colloquium] (July 1973) 'Traditional Modes of Contemplation and Action,' was widely ecumenical. Unlike other such meetings, the initiative came from the East, following the deep wish of John de Menil, founder and first Chairman of the Rothko Chapel. Yusuf Ibish, Professor at the American University of Beirut and a practicing Muslim, was the organizer and prime mover. With the help of a small advisory committee, constituted by a Hindu, an Eastern Christian, and another Muslim, he selected the participants.

The participants were men of faith who viewed their religious tenets from 'inside' rather than 'outside.' Each scholar, each holder of a truth, had treasures to unwrap. These were not displayed for the futile game of proving a point or of justifying an attitude. Rather, they were offered as genuine contributions towards the understanding of the ultimate problems of man, as additional flickers of light for those in quest of 'the Imperishable,' in quest of 'that which cannot be seen by the eye, but that by which eyes have sight.' Sacred music was also part of the colloquium, and this was a recognition of the role of art in religious life."

And further, "Colloquia and events have marked its [the Chapel's] life and traced its vocation. The first colloquium 'Traditional Modes of Contemplation and Action in World Religions' (July 22-30, 1973) had a decisive influence."

The Menil Foundation, Inc., was established in 1954 as a nonprofit charitable corporation to serve as the governing organization for the of works collected by Dominique and John de Menil. As originally constituted, the foundation's purpose was to promote understanding and culture, primarily

through the arts. As an independent institution, the Rothko Chapel is not funded by The Menil Foundation.

◊ Colloquium II, "Human Rights and Human Realities," December 8 and 9, 1973, was inspired by Dom Hélder Câmara, Archbishop of Olinda and Recife, Brazil and organized by the film director and Chapel board member Roberto Rossellini, and staff member Simone Swan. Planned to coincide with the twentieth anniversary of the United Nations Universal Declaration of Human Rights, it was meant to challenge people of faith and of science to an exchange on the fatefully linked issues of human rights and human reality. Among the participants were Dr. Jonas Salk and Dom Hélder Câmara. No written transcripts of comments by Dominique de Menil are known to exist.

◊ Colloquium III, "Toward a New Strategy for Development," February 3-5, 1977, was a direct result of the second colloquium. During three days in February 1977, the economic issues of the world as a whole were discussed by economists and social scientists of widely differing viewpoints. Some came from developing countries – Bangladesh, Brazil, Egypt, and India, others from the industrialized world – mostly Great Britain and the United States. "Toward a New Strategy for Development" provided knowledge and material for reflection for those who, like Dom Hélder Câmara, were committed to liberation. It was organized by Professor James W. Land, Rice University, and participants were Harold Brookfield, Australia; Fernando Enrique Cardoso, Brazil; Richard Cooper, Connecticut; Reginald Green, United Kingdom; Albert O. Hirschman, New Jersey; Nurul Islam, Bangladesh; Fawzy Mansour, Senegal; Bagicha Singh Minhas, India; Goran Ohlin, Switzerland; Dudley Seers, United Kingdom; Paul Streeten, United Kingdom; and Bill Warren, United Kingdom.

◊ "Time of Prayer" took place over ten consecutive Sundays, January through March 1978. For the first time in the city's history, Houston's spiritual leaders, who believed in the unifying power of love, offered prayers in their own traditions while people of diverse religious persuasions witnessed in silent respect. The participants were Muslims, Quakers, Baptists, Hindus, Copts, Jews, Episcopalians, Roman Catholics, Greek Orthodox, Lutherans, Methodists, and Presbyterians.

◊ The Whirling Dervishes came to the Rothko Chapel after Yusuf Ibish, the organizer and a participant in the first colloquium, had a dream in 1973 that Jalaluddin Rumi was whirling around the *Broken Obelisk*. This vision prompted Dominique de Menil to seek out dervishes from Konya, Turkey and invite them to the Chapel. Many people dream but do not necessarily act on their dreams; the de Menils, on the other hand, always tried to realize dreams. Dominique de Menil and Nabila Drooby, executive director of the Rothko Chapel, went to Turkey to meet with the Sufis. They were extremely well received in Turkey and government officials even allowed Mrs. de Menil to sleep in Kamal Ataturk's bed. In Konya, she was greeted by government officials who presented her with the key to the city. After attending the rituals of the Whirling Dervishes, she hand-picked those she invited to the Rothko Chapel.

The Mevlevi Dervishes from Konya, Turkey, appeared at the Rothko Chapel October 15-22, 1978, offering six "Sema" celebrations, ritual ceremonies of music and whirling. Twenty dervishes and musicians, disciples of Jalaluddin Rumi (1203-1273), participated. The Rothko Chapel also sponsored their subsequent tour to Austin, Texas; Washington, D.C.; and New York City.

◊ Congressman Ronald V. Dellums delivered "Towards Justice" on January 15, 1981, the Rothko Chapel's observance of Dr. Martin Luther King, Jr.'s birthday. Following the dedication of *Broken Obelisk* to Dr. King, the Rothko Chapel held an annual celebration of his birthday every year until a day in his honor became a national holiday in 1986. In 2003, the annual observance of his birthday was reinstated.

◊ The First Rothko Chapel Awards for Commitment to Truth and Freedom were presented on June 20, 1981. Recipients of the awards were Giuseppe Alberigo, Italy; Amadou Hampaté Bâ, Mali; Balys Gajauskas, USSR; Douglas and Joan Grant, California; Las Madres de la Plaza de Mayo, Argentina; Ned O'Gorman, New York; Warren Robbins, Washington D.C.; Sakokwenonkwas (Chief Tom Porter), The Mohawk Nation at Akwesasne, Raquette Point, New York; Zwelakhe Sisulu, South Africa; Socorro Juridico and Roberto Cuéllar, El Salvador; Tatiana Velikanova, USSR; and José Zalaquett, Chile.

At the award ceremony Dominique de Menil said, "In 1981 we mark the tenth anniversary of the Rothko Chapel. It is a good time to reaffirm its vocation and question our faithfulness to it."

Fr. André Scrima's program text for the ceremony read: "Since its consecration in 1971, the Rothko Chapel has been dedicated both to contemplation and action. Quite naturally this vocation blossomed into human rights activity, and in 1981 awards for heroic commitment to truth and freedom were presented to twelve organizations and individuals.

Nothing could better express the purpose of the Chapel than to recognize, to name, to single out men and women who in their words, their writings, and their deeds stand for the genuine respect and the safeguard of the fundamental value of man… are we merely going to relate the names of these men and women to what is known all over the world as the 'defense of human rights,' or are we going to understand that what is at stake in their spontaneous struggle is man in his primordial and ultimate truth, man and his dignity as a person, his need to enter into free and fraternal communication with his fellow men, his legitimate longing for the open potentialities of life?

Indeed, what these men and women are revealing goes deeper and well beyond the usual connotations of 'human rights.' They and the multitude they represent bring forth to mind the irrepressible truth of human freedom – a freedom that no authority in the world, be it political, ideological, religious, or economic, should be able to restrict without consent – a freedom belonging to every human being in search of more justice. Once it is recognized that to every 'I' there is 'the other' (irrespective of creed, color, or social status), the principle of fundamental justice is established. Injustice begins as soon as we forget, neglect or deny this; as soon as organized power originally intended to serve man, exercises undisputed domination over its own society. All responsibility is co-responsibility… By our recognition, we are honoring also a struggle for truth – for the redeeming function of truth in front of organized lies."

◊ Colloquium IV, "Islam: Spiritual Message and Quest for Justice," organized by Nadjm ud-Din Bammat, Delegate of the Organization of the Islamic Conference to UNESCO, Paris, was held October 21-25,

1981. It included participation by Etel Adnan, Khurshid Ahmad, Syed Muhammed Naguib al-Attas, Hamid Algar, Muazzam Ali, al-Sadig al-Mahdi, Prince Mohammad al-Faisal al-Saud, Salem Azzam, Sahair el-Calamawy, Hisham Djait, Ahmad Fouatih, Yusuf Ibish, Ahmad Taleb Ibrahimi, Javid Iqbal, Abdel-Aziz Kamel, Ali Kettani, Muhsin Mahdi, Hisham Nashabeh, Abdus Salam, Amadou Seydou, Mohammad Talbi, and Eva de Vitray Meyerovitch.

The goal of the colloquium was a free and open discussion among specialists, each speaking in his or her own individual capacity on various aspects of Islam. The close connection between values and action, between transcendental and everyday ways of life, between the metaphysical and the physical, was stressed. It was an attempt to give, for the first time from within, an authentic image of a civilization which is very present in world affairs and the news today, yet is little known or understood. This colloquium should be considered as integrated within a series of preceding and future activities leading to a respect of all human beings and civilizations and to meaningful dialogue among cultures.

"While economic and political interests are more powerful than ever, the colloquium "Islam: Spiritual Message and Quest for Justice" marks an attempt on the part of distinguished Islamic personalities to search for and express values that are not subordinated to such interests: transcendental values as well as deeply human values; unifying principles as well as respect of and concern for "the other." Thus it takes its natural place within a continuing series of conferences, publications, awards, and other events organized at the Rothko Chapel." (Dominique de Menil, colloquium brochure)

◈ Colloquium V, "Ethnicities and Nations: Processes of Inter-Ethnic Relations in Latin America, Southeast Asia, and the Pacific, was held October 28-30, 1983. This colloquium brought together leading scholars from three major geographic areas of the world to examine the pressures placed on traditional ethnic communities by modern nation-state models of government, with their stress on national unity and on national image. The colloquium was organized by Dr. Francesco Pellizzi, research associate of the Peabody Museum at Harvard University and a board member of the

Rothko Chapel; Dr. Remo Guidieri, University of Paris at Nanterre; and Dr. S.J. Tambiah, Harvard University. No written transcript of Dominique de Menil's welcoming address is known to exist.

◇ On December 10, 1986, the Second Rothko Chapel Awards for Commitment to Truth and Freedom, the first Oscar Romero Award and the Carter-Menil Human Rights Prize were awarded.

Former President Jimmy Carter was the speaker, and the keynote address was delivered by The Most Reverend Desmond M. Tutu, Archbishop of Capetown, South Africa.

Recipients of the Second Rothko Chapel Awards for Commitment to Truth and Freedom were Charter 77, Czechoslovakia; Myles Horton, USA; Helen Joseph and Albertina Sisulu, South Africa; Anatoly Koryagin, USSR; Jonathan Kuttab and Raja Shehadeh, Occupied West Bank; and Sanctuary, USA.

The First Oscar Romero Award recipient was Bishop Leonidas Proaño Villalba, Equador.

The Carter-Menil Human Rights Prize recipients were Grupo de Apoyo Mútuo (The Group for Mutual Support), Guatemala and Yuri Orlov, USSR.

◇ On March 24, 1988, the Second Oscar Romero Award recipient was Paulo Evaristo Cardinal Arns, São Paulo, Brazil. Speakers were to be former Secretary of State Cyrus Vance, former First Lady Rosalynn Carter, and Ambassador Donald B. Easum. Cyrus Vance was unable to attend, so Rosalynn Carter gave the keynote address.

◇ The Yale Institute of Sacred Music, Worship, and the Arts sponsored the "Rothko Symposium" at the Yale University Art Gallery December 1-3, 1989. This symposium was organized to study Mark Rothko's paintings in the context of other selected mid-century American paintings, looking specifically at claims about their subject matter and religious content.

Two areas of interest were raised at the symposium. First, that recent scholarship has drawn attention to religious dimensions in modern paintings, especially in relation to Mark Rothko's work and the commissioning

of the Rothko Chapel. Second, that Marie-Alain Couturier, a French Dominican priest-artist (1897-1954) directly influenced major commissions for religious purposes, such as the churches in Assy, Audincourt, Matisse's chapel in Vence, and Le Courbusier's chapel in Ronchamp. Dominique de Menil donated Fr. Couturier's archives to Yale University.

◇ On April 24, 1990 Senators George Mitchell and Mark Hatfield presented the Rothko Chapel Oscar Romero Award in Caucus Room No. 325 of the Russell Senate Office Building in Washington, D.C. to María Julia Hernández, Director of Tutela Legal and Lutheran Bishop Medardo Gómez. Congressman Joe Moakley was the keynote speaker at the ceremony. Prior to the presentation of the award, Dominique de Menil, with some board members and friends, went to El Salvador on March 24 to announce the recipients of the award at the church where Archbishop Romero was assassinated.

◇ The Carter-Menil Human Rights Prize Foundation (1986-1994) was established by President Jimmy Carter and Dominique de Menil to promote protection of human rights throughout the world. Each year on December 10, the anniversary of the proclamation of Universal Declaration of Human Rights by the United Nations, the foundation presented a $100,000 prize to one or two organizations or individuals for their outstanding contribution to the advancement of human rights principles. The Carter-Menil Human Rights Prize 1990 was presented to the Consejo de Comunidades Etnicas Runujel Junam (CERJ), Guatemala and to the Civil Rights Movement (CRM), Sri Lanka.

◇ "CERJ and CRM are role models of courage and leadership in two countries whose governments have chosen to ignore the voice of truth. Working under difficult, discouraging, and sometimes life-threatening conditions, members of these two groups have struggled dauntlessly to denounce human rights abuses and prevent their future occurrence." (Dominique de Menil, 1990 Carter-Menil Human Rights Prize brochure)

◇ Colloquium VI, "Christianity and Churches on the Eve of the Vatican II," an international conference on the history of Vatican II, organized by the Istituto per le Scienze Religiose (Bologna, Italy) and the Rothko Chapel to mark the twentieth anniversary of the Chapel, brought thirty-three out-

standing scholars and theologians from around the world who attended the Second Vatican Council. Held January 12-15, 1991, the conference helped the Istituto gather first-hand information and documents to record the history of Vatican II. The Chapel gave financial support to the Istituto to document the history of Vatican II, which it published in four volumes.

◊ The Rothko Chapel Award for Commitment to Truth and Freedom, given December 8, 1991, had as keynote speakers Nelson Mandela and former President Jimmy Carter. Award recipients were CONAVIGUA, Guatemala; Ramón Custodio López and CODEH, Honduras; Juan Guillermo Cano Busquets and Ignacio Gómez, Colombia; María Mirtala López and CRIPDES, El Salvador; Ramiro de León Carpio, César Guadamuz and Sebastian Suy Perebal, Guatemala.

Also on December 8, 1991, the Rothko Chapel Oscar Romero Award was presented to Monseñor Rodolfo Quezada Turuño, Bishop of Zacapa, Guatemala.

A special Rothko Chapel Award was given to Nelson Mandela, South Africa.

The Carter-Menil Human Rights Prize was awarded to the University of Central America José Simeón Cañas, San Salvador in memory of six Jesuits murdered on November 16, 1989. Receiving the award from the university were Fr. Miguel Estrada, Rector, and Fr. Charles Beirne, Vice Rector.

◊ Dominique de Menil's acceptance speech on March 8, 1992 was on the occasion of being awarded Assumption University's Christian Culture Series Gold Medal Award in Winsor, Ontario, Canada. She was chosen as a Christian role model for her outstanding contribution to the arts and social justice. Assumption University is administered by the Congregation of St. Basil, the Basilian Fathers.

◊ The Rothko Chapel Oscar Romero Award on June 16, 1993 was presented in Vienna in conjunction with the United Nations World Conference on Human Rights. The Honorable Michael Higgins, Minister of Culture, Ireland was keynote speaker, and the recipient was *Oslobodjenje* of Sarajevo, an independent newspaper with multi-ethnic and multi-religious staff

and reporters. The award was accepted by Gordana Kneževi and Rasim Cerimagi.

◊ On January 11, 1997, the Oscar Romero Award was given to Salima Ghezali, editor of *La Nation*, Algeria; and The Hon. Abdennour Ali-Yahia, attorney and former government minister who denounced human rights violations and was among the first to document them in Algeria. Speakers were The Hon. Ibrahima Fall, Assistant Secretary-General for Human Rights, United Nations, Geneva, Switzerland; Professor William B. Quandt, University of Virginia; and The Reverend Dr. John Fife, Southside Presbyterian Church, Tucson, Arizona.

Additional photo credits:
Anthony Allison, pg. 71
Adelaide de Menil, pg. 88
Hickey-Robertson, ppgs. 67, 68
Wendy Watriss, pg. 85